WATERCOLOR SUCCESS!

52 Essential Lessons for Creating Great Paintings

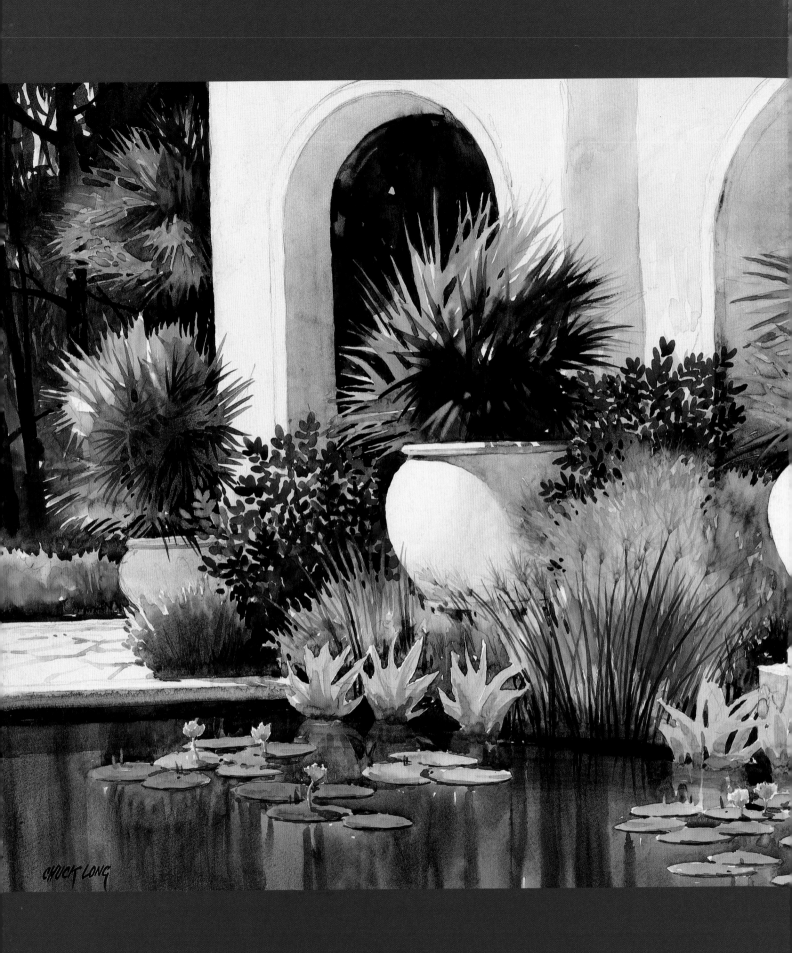

WATERCOLOR SUCCESS!

52 Essential Lessons for Creating Great Paintings

CHUCK LONG

NORTH LIGHT BOOKS
CINCINNATI, OHIO
www.artistsnetwork.com

ABOUT THE AUTHOR

A native of Georgia, Chuck Long is an experienced and innovative artist who began his career as a painter after spending four years in the United States Navy. With help from the G.I. Bill, Long attended the Harris School of Art in Nashville, Tennessee. Upon graduation he worked as a freelance artist, designer and illustrator in both San Francisco and Los Angeles before settling in Alabama. Long currently resides in Huntsville, where he has taught both watercolor and oil painting for over 25 years.

Long's paintings have been featured in several fine art magazines and have won numerous awards at art shows across the country. His work has been showcased in such prestigious exhibitions as American Watercolor Society, Southern Watercolor Society, Georgia Watercolor Society, Watercolor Society of Alabama, Disney World Festival of the Arts, Knickerbocker Artists of New York, and the Arts for the Parks Exhibitions.

ART ON PAGES 2-3:

BALBOA PARK
15" X 20" (38CM X 51CM)

Watercolor Success! : 52 Essential Lessons for Creating Great Paintings. Copyright © 2005 by Chuck Long. Manufactured in China.

Published by North Light Books, an imprint of F+W Publications, Inc., 4700 East Galbraith Road, Cincinnati, Ohio, 45236. (800) 289-0963. First Edition.

Other fine North Light Books are available from your local bookstore, art supply store or direct from the publisher.

09 08 07 06 05 5 4 3 2 1

Library of Congress Cataloging in Publication Data
Long, Chuck
 Watercolor success! : essential lessons for creating great paintings / Chuck Long.— 1st ed.
 p. cm
 Includes index.
 ISBN 1-58180-553-5 (hc. : alk. paper)
 1. Watercolor painting—Technique. I. Title.

ND2420.L65 2005
751.42'2—dc22 2004057653

Edited by Layne Vanover
Cover designed by Davis Stanard
Interior designed by Wendy Dunning
Production art by Amy Wilkin
Production coordinated by Mark Griffin

METRIC CONVERSION CHART

To convert	to	multiply by
Inches	Centimeters	2.54
Centimeters	Inches	0.4
Feet	Centimeters	30.5
Centimeters	Feet	0.03
Yards	Meters	0.9
Meters	Yards	1.1
Sq. Inches	Sq. Centimeters	6.45
Sq. Centimeters	Sq. Inches	0.16
Sq. Feet	Sq. Meters	0.09
Sq. Meters	Sq. Feet	10.8
Sq. Yards	Sq. Meters	0.8
Sq. Meters	Sq. Yards	1.2
Pounds	Kilograms	0.45
Kilograms	Pounds	2.2
Ounces	Grams	28.3
Grams	Ounces	0.035

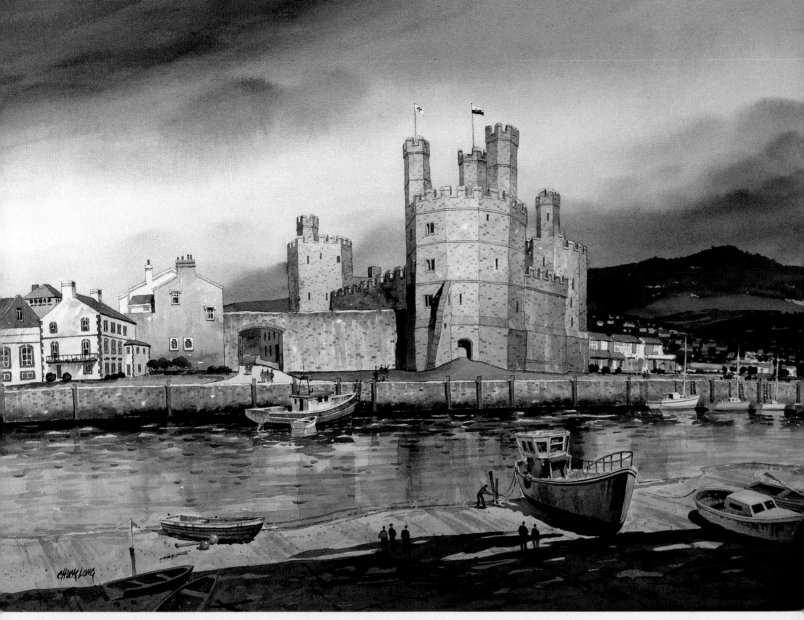

CAERNARFON CASTLE, WALES
15" X 20" (38CM X 51CM)

ACKNOWLEDGMENTS

Thanks to my students, past and present, who provided the need for this book and the push to get it done. Thanks to the folks at North Light Books and to Rachel Wolf, who guided my book through the acquisitions process. Special thanks to my editor, Layne Vanover, whose professional wisdom, patience and guidance helped me over many rough spots. And last but certainly not least, thanks to my family—Mary Lou, Steve, Vanessa, Eric, Bill, Barry, Haley and Dylan. Your love, devotion and physical hands-on help was invaluable, especially when it came to using the computer!

DEDICATION

I dedicate this book to my dearly beloved wife and family. Without their wholehearted support, encouragement and guidance, this book could not have happened.

TABLE OF CONTENTS

CHAPTER ONE
NECESSARY MATERIALS TO GET STARTED 10

CHAPTER TWO
COLOR CONCEPTS AND PAINT PROPERTIES 22

CHAPTER THREE
DESIGN ELEMENTS AND PRINCIPLES 40

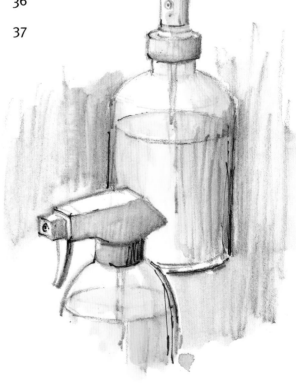

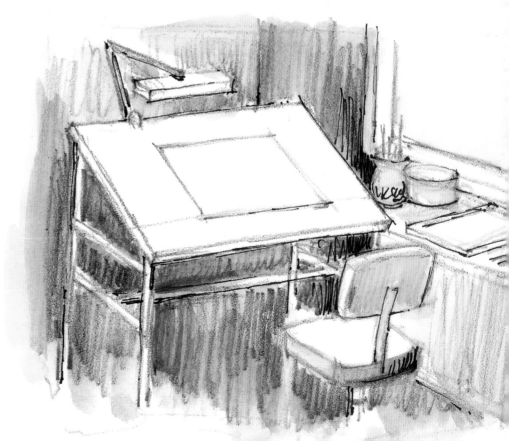

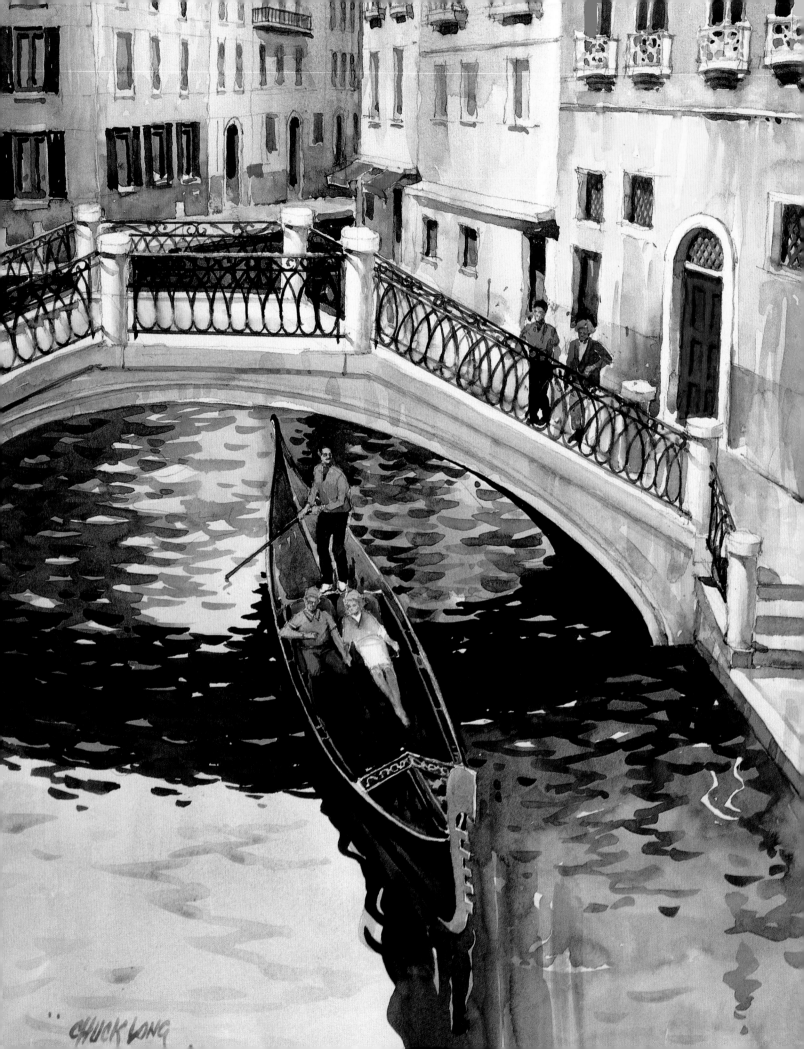

INTRODUCTION

Though the act of painting in any medium brings me great joy, I can confidently assert that I am first and foremost a watercolorist by choice. Watercolor, after all, is the medium that best simulates the illusive nature of light, allowing the artist to create the grandest of illusions on his paper. The brilliant fluency of the paint, the transparency that allows light to penetrate through color, the layering capabilities that give one's paintings a sense of depth and dimension—all of these characteristics work together to create a richness, sparkle and vibrancy that no other medium can replicate. For this reason I find that nothing can take the place of watercolor—it is truly grand. I can only hope that my passion for this remarkable medium inspires you to take brush in hand and begin your very own love affair with watercolor painting.

In a general sense, painting can be defined as creating the illusion of three dimensions on a two-dimensional surface by varying colors and values to simulate light and shadow, thereby visually establishing shape, form and texture. This is certainly a mouthful, but that's my story and I'm sticking to it! All the fundamentals of painting are contained within this definition; it's painting in a nutshell. However, to become a successful artist you must crack this shell, learning the essential lessons necessary to develop your skills as a watercolor painter. This book will help you do just that. You'll read about important elements of painting such as color concepts, techniques, the basics of drawing, and how to design an appealing composition. Add to this the imperative information about materials and tools that will enable you to get started, and you're all set! In no time you'll be creating solid and successful paintings of your own!

For better or worse, this book is written as if I am talking to my students. The subject matter chosen for my paintings, as well as the concepts, methods and materials discussed within this book, all reflect my personal preferences and beliefs. As you grow as a painter, you may find that your preferences and beliefs differ from my own. This is fine. I encourage you to discover what works best for you and to develop your own individual style. My intention is simply to leave you with the essential lessons that will help you get started on your watercolor journey. If this book succeeds in imparting knowledge that will help you become the best artist you can be, then I have achieved my goal.

I wish you the best of luck in your painting endeavors. Remember that hard work and experimentation are the essentials for creating great paintings. And the age-old joke about how to get to Carnegie Hall always applies—practice, practice, practice!

A CANAL IN VENICE
20" X 15" (51CM X 38CM)

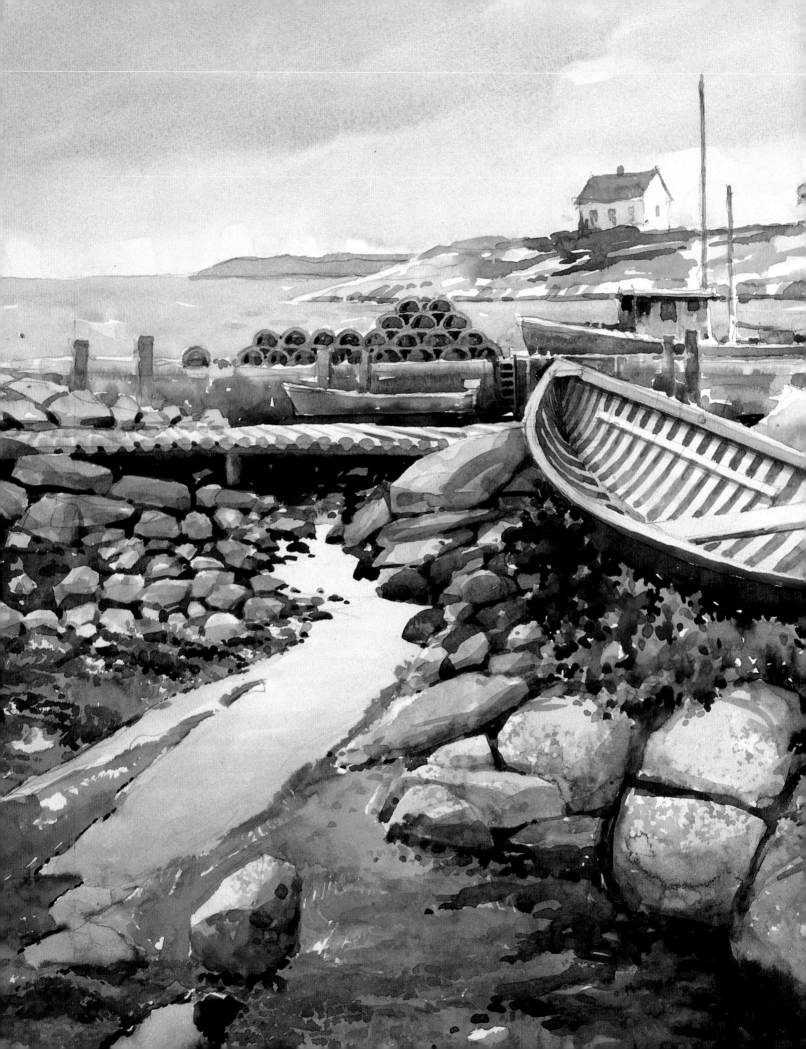

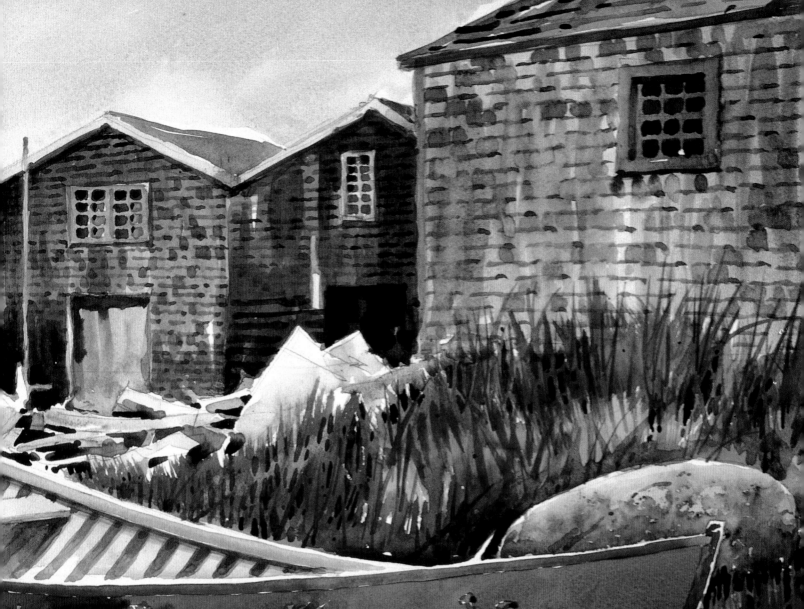

1 NECESSARY MATERIALS TO GET STARTED

PEGGY'S COVE
15" X 20" (38CM X 51CM)

PAPER

Watercolor paper comes in various weights, surface textures and sizes. Moreover, you can purchase watercolor paper in individual sheets (or rolls), blocks or pads. I advise you to experiment with different types of paper, finding one that you feel comfortable with and that will perform well for your paintings.

Paper Weights

Watercolor paper comes in numerous weights, the lightest being 90-lb. (190gsm) and the heaviest being 400-lb. (850gsm). The thinner or lighter the paper, the less it costs. Some of the more popular paper weight choices for watercolorists are 140-lb. (300gsm) and 300-lb (640gsm). Paper weight is determined by stacking a ream, or 500 sheets, of 22" x 30" (56cm x 76cm) paper on a scale. The total weight becomes the designated weight of that particular paper. Any paper under 200-lb. (425gsm) needs to be stretched (see next page) so that it stays flat while you work. It isn't fun to work on wavy or buckled paper.

Paper Textures

Watercolor paper comes in three textures—*hot-pressed, cold-pressed* and *rough*. Hot-pressed is extremely smooth and has a hard finish due to the application of heat and pressure in the paper-forming process. Cold-pressed has a medium texture with a certain amount of tooth to the surface. Rough, as the name implies, is extremely textured, or has a lot of tooth. Each of these textures creates its own unique effects. Cold-pressed is the surface most commonly used by watercolorists.

Forms of Paper

Watercolor paper can be purchased in several forms. Individual sheets of paper are the most popular form. These sheets are usually 22" x 30" (56cm x 76cm) in size. You can also find elephant (23" x 28" [58cm x 71cm]) and double elephant (26 ½ " x 40" [67cm x 102cm]) size paper, as well as rolls that are 42" (107cm) to 51" (130cm) wide by several yards in length.

Hot-Pressed Paper

Hot-pressed paper, being smooth and hard, absorbs less paint and therefore dries quickly. This surface can show more brushstrokes and create more *blossoms* (see page 56). These effects give a hot-pressed watercolor a sketchier look that can be appealing.

Watercolor blocks are made up of a number of sheets fastened to a chipboard base. A painting can be executed on the top sheet and peeled off, providing a fresh sheet for the next painting. Block sizes range from 7" x 10" (18cm x 25cm) to 18" x 24" (46cm x 61cm). Smaller blocks are very useful when traveling or sketching in the field.

Cold-Pressed Paper

This medium-surface paper is soft, dries moderately fast, and absorbs some paint into the paper. It works well for laying down even layers of color. It also has some tooth, or texture, which the painter can exploit to produce textured objects such as tree bark, rough rocks or weathered wood.

Rough Paper

Rough paper is very soft and extremely rough, producing exaggerated textures. It has greater absorbency and is slow drying. The roughness is so great that the high points and valleys can cause uneven lighting across the surface, distorting color and values.

EXERCISE | STRETCHING YOUR PAPER

One problem you will notice with 140-lb. (300gsm) or lighter watercolor paper is that it tends to expand, buckle and wave when it gets wet. As a result, lighter papers need to be stretched before you begin painting. Stretching your paper ensures that it will stay firm and flat while painting, giving you greater control over paint applications.

The paper-stretching process consists of four easy steps: wetting your paper, allowing your paper to expand, draining your paper thoroughly, and fastening your paper to a board. Better still, few materials are required to stretch paper. You will need a board that is slightly larger than your paper and somewhat absorbent. Wooden drawing boards made of plywood or particle board work well. You will also need a large pan to hold water. I prefer to use a deep serving tray, though your bathtub will work fine in a pinch. Grab your sponge, some paper towels and a roll of gummed tape to round out your materials, and you're ready to begin!

MATERIALS LIST

Surface — ½ sheet 140-lb. (300gsm) watercolor paper

Other — Gummed tape
Large pan (preferably a serving tray)
Paper towels
Sponge
Wooden drawing board

1 Immerse Paper in Water
Fill your pan with lukewarm water. Immerse your sheet of paper in the water, rocking the tray slightly to make sure the entire sheet is soaked through.

2 Allow Paper to Expand
Work the sheet back and forth under the water for fifteen minutes, letting it soak up the water and expand. If you need to rest, it's okay to let the paper fold back on itself. Just keep as much of the paper under water as possible.

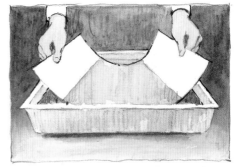

3 Remove Paper From Tray
After the paper has soaked for at least fifteen minutes, carefully remove it from the water. Drain the paper thoroughly, holding it over the tray and allowing excess water to drip back into the pan.

CONSIDER THE ALTERNATIVE

If you want to use lightweight paper but would like to avoid the paper-stretching process, consider buying watercolor board, a thin sheet of watercolor paper fixed onto heavy chipboard. Because the paper is already secured to the board, you don't have to stretch the paper before you begin painting. Though you can't immerse this board under water as you can sheets of paper, it works beautifully when you selectively wet parts of the surface and paint within those areas.

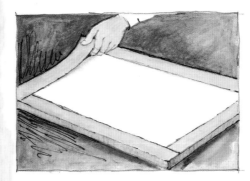

4 Fasten Paper to Your Board
Lay your paper flat on the board and remove excess moisture around the edges with a paper towel. Moderately wet several strips of tape with your sponge, placing them around the edges of the paper to secure it to your board. Keep the board horizontal and allow your paper to dry.

BRUSHES

There are a number of factors to consider when choosing watercolor brushes, including brush hair, shape and size. With such a great variety of brushes available in the marketplace, you may feel overwhelmed when shopping. In an effort to simplify your search for the perfect brushes, this section outlines some of the more popular choices. I encourage you to experiment with a selection of brushes, familiarizing yourself with the strengths and weaknesses of each brush. Over time you will develop your own preferences and use the brushes that provide the best fit for your painting style and needs.

Brush Hair

Watercolor brushes are made using natural or synthetic hair, as well as blends of natural and synthetic fibers. Natural hair brushes include sable, sabeline, ox-hair and camel-hair brushes. Most synthetic brushes are made from nylon, which is sometimes dyed to look like natural hair.

BRUSH CARE

All brushes eventually wear out, but following these pointers will help them last longer:

- Thoroughly clean your brushes after each use and store them in a container, bristle end up.
- Keep your brushes out of water except when actual painting is taking place.
- Don't use your good watercolor brushes to scrub; there are cheap brushes made specifically for this purpose.
- In between uses, shape bristles to a point using soap. (Remember to wash the soap out before using the brush.)

There is a direct correlation between the cost of a watercolor brush and the hair used to make the brush. By far, the most expensive brush available is the pure red sable. Synthetic brushes tend to be the cheapest on the market. For the most part, I find less expensive brushes perform just as well as their pricier counterparts, only falling short of sable brushes in pointability and durability.

SABLE A kolinsky sable is an animal from Siberia sought out for its fur. In particular, the hair from the sable's tail is used to make watercolor brushes. A no. 12 pure red sable brush can cost well over $200. Many artists swear by these high-quality brushes because of their durability and pointability. If properly cared for, sable brushes will seemingly last forever. They are especially vulnerable to moths, though, and should be sealed and packed with moth balls for protection when stored for long periods of time.

SABELINE A much less expensive natural hair brush is the sabeline. These strong, resilient brushes are favored by numerous watercolorists. Sabelines are quality performance brushes, even though they don't point as well as sables or some synthetics.

OX HAIR AND CAMEL HAIR Another cheaper alternative to the sable brush is the ox-hair brush. These natural hair brushes are generally well-suited for watercolor. Similar to sabelines, ox-hair brushes are springy, fairly long lasting and weak in pointability.

Conversely, camel-hair brushes (mostly made from squirrel hair) aren't good for general watercolor painting, as they are too soft and inflexible. However, large, flat camel-hair brushes work well for painting skies.

SYNTHETIC AND NATURAL/SYNTHETIC BLEND Synthetic brushes have become popular in the last few years. Mostly made from nylon, they have a well-defined point and are reasonably durable. However, price may be the biggest factor in their growing popularity, as they are inexpensive and can be replaced easily when they wear out.

You can also buy brushes with blends of synthetic and natural hair. These are a little more expensive than pure synthetics (the more real hair, the more expensive the brush), but perform much the same.

Brush Shape

When shopping for watercolor brushes, you will notice that there is a wide variety of shapes to choose from. Some of the more popular brush shapes include the *round*, *flat* and *rigger*. Other useful brushes include *fans*, *brights* and *filberts*. Each of these brushes perform essential functions for the watercolorist, whether it be covering large areas of your paper or painting details.

ROUND BRUSHES A round brush, as the name implies, is a round, pointed brush that can be used for general painting and detail. The larger rounds work well for covering expansive areas, and smaller ones allow you to get into tight spaces. Sizes range from no. 00 (small) to no. 36 (large). There are about twenty

Round Brushes

STARTER BRUSHES

If you can afford six brushes, I would recommend nos. 3, 8, 10, 12, 14 and 26 rounds. If starting out with only three brushes, purchase nos. 3, 8 and 12 rounds. Both sets should be supplemented with a 1-inch (25mm) flat.

Flats

brushes within this range. A well-equipped painter usually has five or six rounds, though you can get started with only two or three.

FLAT BRUSHES These brushes have a flat, square leading edge much like a chisel. They range in size from about ¼-inch (6mm) to 3-inch (76mm). Some artists prefer flats to rounds and do most of their painting with this brush, using the broad end for large strokes and the corner for small areas or thin lines. I have a number of flat brushes and find the 1-inch (25mm), 1½-inch (38mm) and 2-inch (51mm) indispensable for painting skies and covering large areas.

RIGGERS Riggers or script liners are long, thin rounds with a chopped-off tip. These brushes can be loaded with paint to produce long thin lines without running out of paint quickly. Riggers are excellent for painting objects such as tree limbs, power lines, wire fences and the rigging on sailing ships (hence the name rigger). Riggers range from nos. 1–6, no. 1 being the thinnest and no. 6 being the thickest. I prefer white nylon riggers because of their springiness and durability, but they come in all types of fibers.

OTHER USEFUL BRUSHES There are a couple of other brushes I have found useful over the years, including a no. 3 hog-bristle fan blender. Though traditionally used by oil painters, I find that it is an extremely easy brush to use for watercolor. Its stiff fan shape works well for painting grass textures and the foliage for trees and shrubs. By raking the brush, using the corner or twisting it, you can create interesting effects and textures.

Another useful brush is a stiff hog-bristle brush. This oil-painting brush is ideal for scrubbing out already painted and dried areas. A no. 4 bright (shortened flat) or filbert works for this task as well. Remember to be gentle to avoid damaging your paper.

Riggers

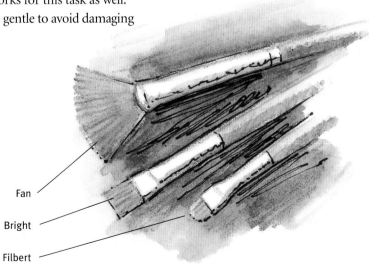

Fan

Bright

Filbert

Other Useful Brushes

PAINTS

All paints are made using pigments, binders and vehicles. *Pigments* are the materials that provide the color in paints. The pigments used in almost every type of paint are fairly similar, although some paints use a stronger concentration of pigments. The major differences lie in the *binders* and *vehicles* used, which hold the pigments together and allow the paint to adhere to your painting surface.

Professional-grade paints are made with the finest pigments (derived from minerals and organic compounds) and the highest quality binders and vehicles (e.g., gum arabic). Conversely, student-grade paints use fewer pigments and more fillers, as well as inferior-quality binders and vehicles. As a result, student-grade paints are less vibrant in color and less fluid, making them considerably cheaper in price. Though student-grade paints are acceptable to use when you are first learning and experimenting with watercolor, I recommend that you advance to professional-grade paints as soon as you feel comfortable with the medium. Professional-grade paints will last longer and give you better results.

You can purchase watercolor paints in several forms. Among the most commonly used are watercolor tubes and pans. Tube paints are popular for several reasons: They are convenient to transport and store; they are an instant source of clean, fresh pigment; and there is an almost unlimited selection of colors.

Watercolor pans are also popular. The quality of these paints is equal to that of tubes, they are just stored in a different form. Professional pan sets have replaceable pans of paint and a built-in mixing tray with room to store a brush or two. Such sets can be fairly expensive. Half pans, or smaller pan sets, are slightly cheaper and very compact, making them convenient for travel.

In addition to tubes and pans, watercolor paints also come in cakes, liquids and pencils.

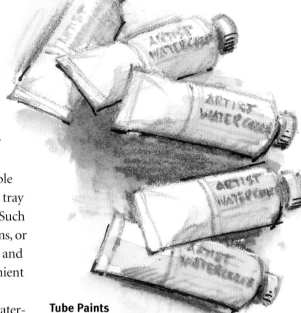

Tube Paints

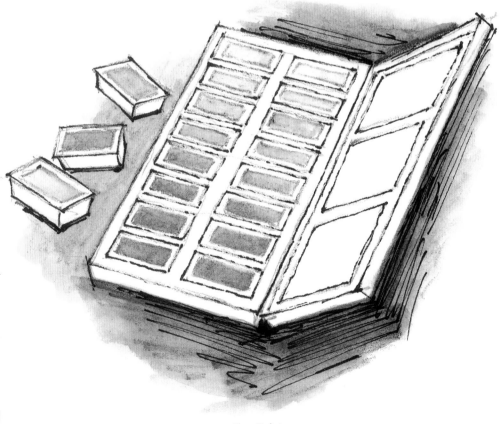

Pan Paints

QUALITY PAINTS GIVE QUALITY RESULTS

Always buy the best quality paints that you can afford. Not only do these paints perform better, they also last longer. Equally important, using quality paints can help you become a better painter, as the pigments are brighter and more vibrant, giving you satisfactory results.

PALETTES

Watercolor palettes are made from various materials, including plastic, glass and enamel. Any surface that you choose will work, though, as long as it is smooth and easily cleaned.

Palettes also come in different shapes and sizes. Some artists use circular palettes, while others prefer rectangular shapes. Regardless your preference, it is important to purchase a palette that is adequate in size. Larger palettes work best, as they have substantial space for placing your pigments and mixing colors. Also be sure to choose a palette with a white surface, as this allows you to better judge the colors you are mixing.

Another choice you will be faced with when selecting a palette is whether or not you want a surface with wells, or compartments for storing your pigments. As a beginner, you may find it easiest to use a palette that has wells around the perimeter and a space in the center for mixing purposes. Palettes with wells may also be used for storing large batches of mixed color that you may want to save and use again later in the same painting.

Rectangular Palettes
Plastic rectangular palettes are easy to use for the watercolorist. I especially like the John Pike palette because the large mixing surface is easy to access from the paint wells on the outer edges. Any palette will work as long as it is large and white. Remember, watercolor paints are transparent, so the white background lets you know what color you have mixed.

THE BUTCHER'S TRAY

My all-time favorite palette is a porcelain-enameled steel tray, better known as a butcher's tray. Originally these trays were used to display fresh cuts of meat in the market, but have long since been replaced by styrofoam trays and shrink wrap. Today, they serve as a great palette for the watercolor artist. Not only do they provide a generous amount of mixing space, but the absence of wells makes it easy to mix colors, as there are no barriers between your paints and the mixing area. In addition, I find the porcelain surface to be smoother and easier to clean than other palettes.

Circular Palettes
Some artists prefer round watercolor palettes. There is a wide variety of round palettes to choose from. Some even have thumb holes so you can hold the palette while painting. If you choose to work with a circular palette, find the largest palette available to maximize your mixing space.

ADDITIONAL TOOLS

In addition to the essential watercolor materials, you will need a variety of supplemental tools to assist you when painting. The tools showcased in this section will be used to complete the demonstrations throughout this book. Experiment with these tools and others to discover what works well for you.

Knives

Craft knives, utility knives or razor blades can be used for numerous tasks, including cutting paper or board, removing sheets from a watercolor block, and sharpening your art pencils. They can also be used to scrape out lighter areas in a dried painting or to scratch white lines. This process is just a matter of removing a thin layer of paper that has been painted, exposing the pure white paper underneath. Be careful not to overdo it, though, as a little bit of this effect goes a long way.

Sponges

Both natural and synthetic sponges are very useful to the watercolor painter. They hold generous loads of water and can be used to wet down the paper completely or in controlled areas. They also serve as great texture-making tools. By simply using your sponge to pick up paint from the palette and then pressing it down on your paper, you can impart textured effects from the physical characteristics of the sponge. Though I use both natural and artificial sponges, I am particularly fond of artificial sponges. I feel they have the proper proportion of positive and negative space (negative space being the holes in the sponge) to achieve the desired texture on paper. I call these my "holey sponges" (pun intended) because of their likeness to Swiss cheese.

Masking Fluid

Masking fluid is a liquid latex you apply over an area of your painting that you want to keep white or paint lighter washes over later. When an area has been masked, you can paint freely around or on top of it without worrying about the area absorbing pigment. Once you are finished painting, the dried masking fluid can be peeled off to expose the white paper. It is a great tool when you can't paint around an object or shape quickly enough to keep a background color uniform and clean. However, try not to overuse masking fluid—you don't want it to become too much of a crutch. I use masking fluid only when I absolutely have to.

Spray Bottle

A spray bottle will help you rewet areas of your paper or make already wet areas more fluid. It is also useful for moisturizing and softening dried pigments on your palette. This is a tool that you probably already have around the house. An old hairspray bottle works fine; just be sure to wash it out well before using.

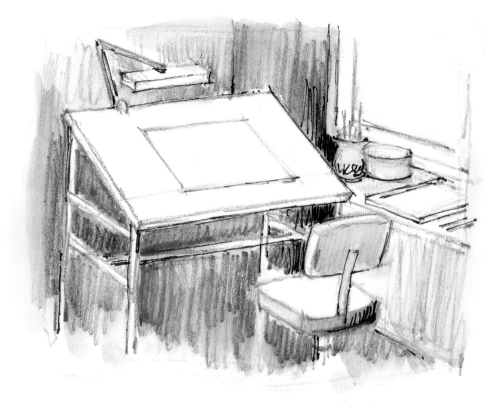

Work Table or Board

You'll need a steady work surface for supporting your watercolor paper, block or board. In a studio setup, you should have a table roughly 24" x 36" (61cm x 91cm) or 30"x 48" (76cm x 122cm). The surface of your table should be sloped about 25 degrees for easy viewing and to allow your paint to flow downward.

You can also use a Masonite, plywood or foamboard surface, either propped up on a flat table or resting in your lap and supported by a flat table. It almost goes without saying—don't wear your Sunday best while painting like this! A side table or shelf is good for accommodating your palette, paints, brushes, water container and other materials.

OTHER USEFUL ITEMS

Masking tape

Masking tape is good for fastening the paper to your work board. Use this tape on dry paper, as it will not adhere to wet surfaces. On wet paper, a gummed tape will work.

Pencils

Graphite pencils that are about a no. 2 yellow commercial grade or an HB artist's pencil will be fine for sketching your scene before beginning your painting. These are also good for doing preliminary value sketches when planning your composition.

Erasers

Kneaded erasers are soft, malleable, and work well to erase unwanted pencil lines without damaging the paper. You can clean these erasers by kneading (like dough).

Water Containers

Water containers should be reasonably large, flat, and have a big opening at the top. Such a container ensures that your water stays cleaner longer, and the low center of gravity prevents the container from tipping over. You can reuse everyday containers like plastic margarine tubs for your water container. I use a very large, flat goldfish bowl in my studio and a cut-off plastic milk container for traveling and painting outdoors.

Paper Towels

Paper towels, facial tissues or rags are good for blotting wetness from your painting, lifting out areas, and cleaning your brushes and palette. They also come in handy for cleaning up spills and messes around your studio.

Carrying Cases

Fishing tackle boxes make excellent containers and carrying cases for your painting materials. Don't get one that is too small, as your materials will probably grow as you do more painting and experiment with new tools.

Brush Holders

Brush holders are available commercially or can be made from canvas or split bamboo place mats. These keep your brushes from being bent, split or otherwise damaged, especially when traveling.

PAINTING LOCATION

Once you've gathered all the tools necessary to begin your watercolor journey, it is time to consider painting location. As an artist, you may choose to paint either indoors (in the studio) or outdoors (on location). Both locations have their own benefits and setbacks. Try painting in both settings to get a feel for what you prefer.

Painting Indoors

Painting indoors is what most artists do the majority of the time, as it is both comfortable and convenient. Just picture it. You're in a room where the temperature is always just right and there is plenty of water on hand. The bathroom and kitchen aren't too far away, and maybe there's even a couch when you're ready to take a break. Relaxing music plays softly in the background, and a hot mug of coffee or tea is readily available when you need to recharge. Sounds just like home, doesn't it? Well, it is home for most artists, and it's all very nice.

As this scenario shows, painting indoors is beneficial for a number of reasons, all of which are connected to comfort and convenience. One of the obvious advantages of painting indoors is having a permanent setup. When working in your studio, you're guaranteed a solid and steady work surface, a comfortable chair or stool, and immediate access to all essential supplies. Moreover, if you run out of paint, paper or other items, you are likely to have more stock in your cabinets or drawers. Working indoors also provides you with access to electricity. This comes in handy for the artist who likes to make use of optional tools such as hair dryers or slide projectors.

Another advantage is that painting indoors frees the artist from having to worry about lighting or weather conditions. Proper lighting is one of the most important considerations for an artist. Though painting in natural daylight whenever possible is best, the use of supplemental artificial light sources ensures that you can paint on the gloomiest of days, as well as during evening hours.

When shopping for artificial light sources, I strongly recommend purchasing fluorescent bulbs. I use two fluorescent lamps as my supplemental light sources: one emits cool light and the other emits warm (natural) light. If painting on dreary days or at night, I use this balanced artificial light. You may also consider purchasing lamps that simulate natural light. However, avoid using incandescent lights in your studio. These bulbs produce a strong yellowish light, skewing your perception of both color and value.

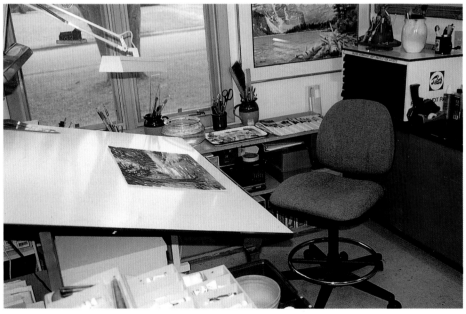

Indoor Setup
Notice that my work station is set up near a window so that I can take advantage of natural light. And, since I am right-handed, I keep my palette and brushes to my right for convenience.

NATURAL LIGHT IN YOUR STUDIO

It is essential for every studio to have access to natural light, so choose a room with at least one window. Light reflected through a window facing the northern sky is the best natural light source for indoor painters. Direct sunlight coming through the window tends to be extremely warm and can harm your painting's surface. Since the sun never shines directly through a window that faces north, light from the northern sky is cooler and more equalized. Thus, painting in north light assures that your color applications will be better balanced and will look the same under most lighting conditions.

BEWARE OF THE SUN

As an outdoor painter, you need to take precautions to protect yourself from the sun. Following these pointers can make your plein air experience more comfortable and pleasant.

- Always wear a hat. This will shield your eyes from the harsh rays of the sun.
- If you burn easily, considering wearing long sleeves or sunblock. A large white umbrella may be useful, as it lets the light through but not the sun's rays.
- Never paint so that the sun is directly on your watercolor paper. Not only can this harm your eyes, but it also makes it very difficult to gauge your colors and values.

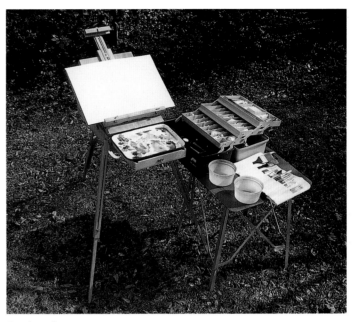

Outdoor Setup
This is my outdoor setup. A tackle box works well for holding paints and other tools, and I bring along a small folding table for my materials.

As a result, paintings executed in incandescent light will look totally different in any other lighting condition.

Painting Outdoors

Whereas painting indoors offers the artist comfort and convenience, painting outdoors promises adventure. Not only is it exhilarating to see your chosen subject firsthand, but painting outdoors gives you the opportunity to be an integral part of the scenery. As such, you're able to *feel* your subject with all of your senses, an experience that can't be duplicated when painting from a photograph. In short, the authenticity of painting outdoors is an intoxicating experience that every artist should try at least once!

As exciting as it may be, however, painting outdoors does require more planning and preparation than painting indoors. Of the items on the plein air painter's agenda, packing all of the essential materials necessary to complete a successful painting is at the top of the list. Transporting everything that you need for painting is vital. Remember, if you run out of supplies while painting on location, you can't run to your art cabinet! Be prepared by making a checklist to ensure everything gets packed. At minimum you will need a watercolor box with eight to twelve pans of color and a small mixing area, several containers of clean water, a few small- to medium-sized brushes and paper. You may also want to bring a small folding easel and a chair. To minimize the amount of materials you have to carry to your destination (and the number of trips you have to make to your car), use a backpack. This will free up both of your hands to carry larger items, such as lawn chairs or small tray tables.

The unpredictable nature of weather may be the biggest disadvantage to painting outdoors. To make the most of your experience, take the time to investigate the forecast before heading out. And even if the weatherman calls for clear skies, it never hurts to come prepared!

For example, it's a good idea to bring a large garbage bag to protect your painting in the event of rain. Also, be ready to make adjustments in your painting depending on the day's weather. If it is warm and there is a breeze, your paints will dry faster. Take this into consideration and adjust your painting techniques or methods if necessary.

Lighting is also an imperative consideration for painting outdoors. It's important to remember that the sun shifts throughout the day, causing the lighting to change. To ensure that the colors and values in your painting are consistent you will need to work quickly. In addition, you'll want to avoid painting at certain times of the day. During the two or three hours around noon, the sun is directly overhead, resulting in a lack of cast shadows. So get to the site early and start painting by eight or nine o'clock. You will have good lighting until roughly eleven, and then again from two until about five.

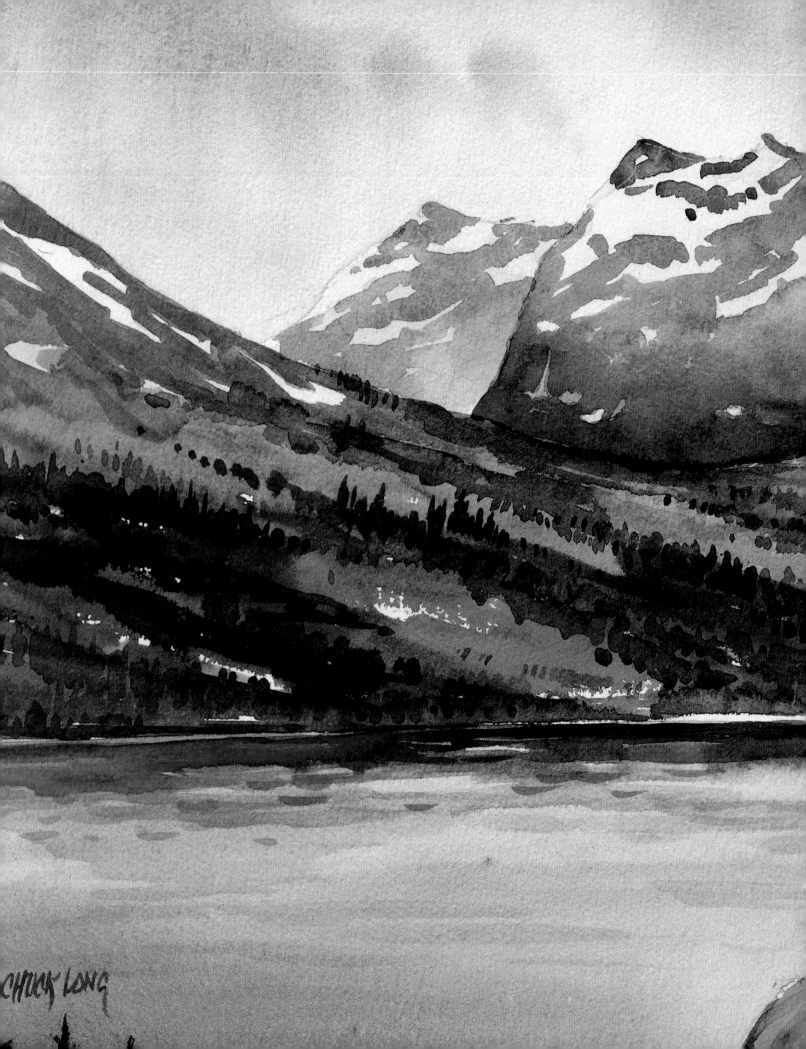

2 COLOR CONCEPTS AND PAINT PROPERTIES

MONTANA MOUNTAINS AND LAKE
11" X 15" (28CM X 38CM)

THE COLOR WHEEL

The color wheel displays all colors in the visible spectrum. There are twelve colors on the color wheel—three *primary*, three *secondary* and six *tertiary*. The three primary colors—red, yellow and blue— are those which cannot be broken down further. These three colors are placed equidistant from each other on the color wheel, forming a triad. All other colors in the visible spectrum are made from these colors. Primary colors, then, could be compared to the basic elements of chemistry: They cannot be created with anything else, yet are used to create all other colors.

The secondary colors—orange, green and violet—are made by mixing two primaries together. In specific, red and yellow produce orange, blue and yellow make green, and red and blue create violet. Notice that these three colors also are placed equidistant from each other on the color wheel, forming a triad.

The third set of colors in the spectrum are the tertiary colors. These are made by mixing a primary with a secondary. For example, red and orange make red-orange, blue and green make blue-green, and red and violet make red-violet. The six tertiary colors lie on the color wheel between the primary and secondary colors that were used to mix them.

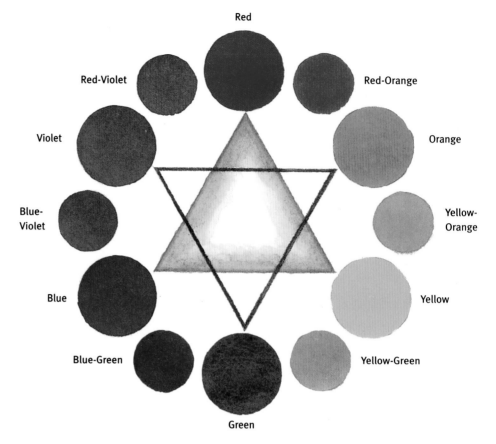

The Color Wheel
The three primary colors—red, yellow and blue—are equidistant from each other on the color wheel, forming a triad. The same is true of the three secondary colors: orange, green and violet. Each tertiary color is located between the primary and secondary colors used to mix it. For example, red-orange falls between red and orange on the color wheel.

A WORD ON NEUTRAL COLORS

After examining the color wheel, you may find yourself wondering where neutral colors fit into the scheme of things. True neutral colors are not seen on most color wheels because they are achromatic (without color). Black, gray and white are considered true neutrals. Earth colors like browns, siennas and umbers are sometimes classified as neutrals, too. All of these colors can be purchased already made or mixed using the colors from the spectrum. I find it best to mix my own grays (see page 27) and leave the white of my paper in areas where I wish to use white. I recommend avoiding tube black, as it can make your paintings look unnatural. Conversely, tube earth colors work well and can be purchased from a variety of manufacturers.

COMPLEMENTARY COLORS

Colors that are directly opposite each other on the color wheel are known as *complementary colors.* Green lies opposite of red on the triadic wheel, making these two colors a complementary pair. The same is true of yellow and violet and blue and orange. If you look closely at the color wheel, you will notice that the complement of any primary color is the combination of the two remaining primary colors. For example, the complement of the primary color blue would be the combination of red and yellow, or orange.

Because the colors in a complementary pair share no common colors, they work well for creating contrast and interest in your paintings. Placing yellow against violet, for example, will draw more attention than placing red against violet. This is because yellow, unlike red, is not a component used to create violet. Consider using complementary colors, then, when you want to spruce up a passage or make it more appealing.

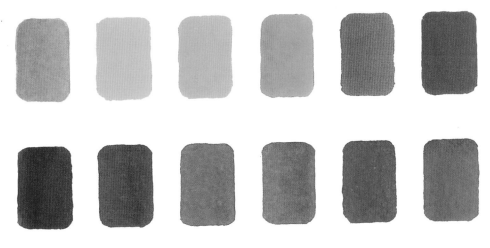

Complementary Color Chart
Here we see each of the twelve colors on the triadic color wheel paired with its complement. Notice how vibrant each color looks when placed next to its opposite, hence the name complementary.

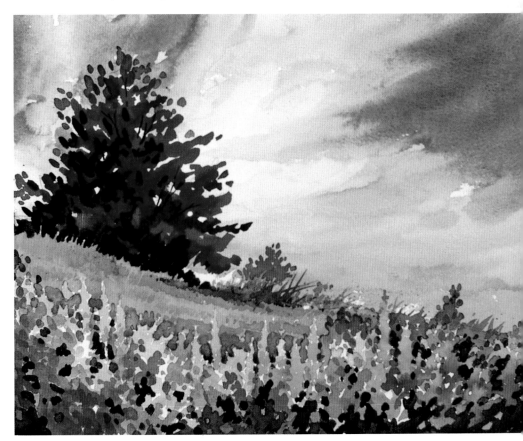

Complementary Colors Create Contrast
To create a sense of interest in this painting, I used the three primary colors and their complements. The contrast between blue and orange in the sky, red and green in the tree, and yellow and violet in the flowers helps to set each area apart from the next.

SPRING
15" X 20" (38CM X 51CM)

ANALOGOUS COLORS

Sometimes referred to as families of color, *analogous colors* are a group of colors adjacent to each other on the color wheel that are closely related in composition and temperature (see page 28). For example, blue, blue-green and green are analogous colors, as they all contain blue and are considered cool in temperature.

Using analogous colors in your color scheme will usually give your paintings a head start towards achieving harmony and unity. With no wild contrasts of color or color temperature, the composition will hold together and flow more smoothly.

Analogous Colors Establish Harmony
The combination of yellows, yellow-greens, yellow-browns and browns conveys a warm mood and helps create a strong sense of harmony between the elements in the painting.

DEEP IN THE FOREST
22" X 15"
(56CM X 38CM)

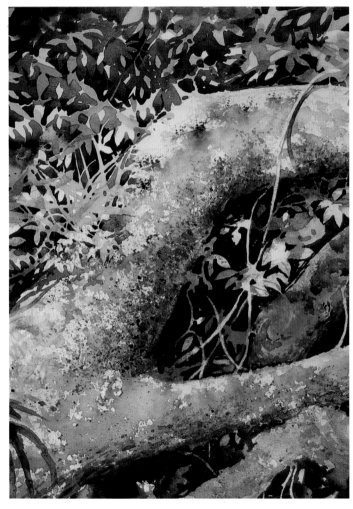

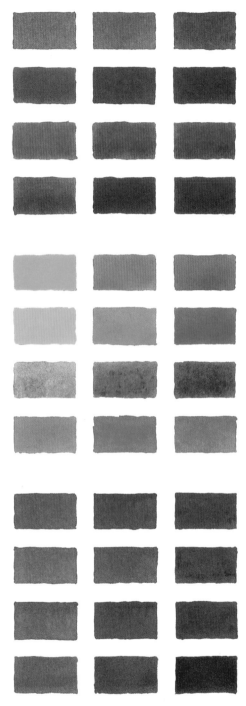

Analogous Color Chart
This color chart shows colors in the red family, yellow family and blue family. These are not all of the colors or color families by any means, but it gives you a pretty good idea as to how colors can be grouped together by their similarities or analogous characteristics.

BREAK THE MONOTONY

Though using an analogous color scheme helps ensure color harmony, using too many similar colors can sometimes result in a monotonous, monochromatic appearance. If you find this happening in your paintings, try placing complementary colors here and there throughout the composition to maintain the viewer's interest. This will help stimulate the viewer's eye and keep it moving through your painting.

PURITY vs. GRAYABILITY

A *pure* color is one that has not been contaminated by other colors and is full of intensity and saturation. Such colors rarely exist in nature. Rather, most colors we observe are *grayed*, with their purity neutralized or diluted by other colors. Since there will usually be more grayed color than pure color within a scene or composition, knowing when, why and how to gray colors is an important part of color mixing. One way to gray a pure color is to add its complement. When complements are mixed together they neutralize each other, creating gray. Using two complementary colors in the proper proportion will give you an absolute neutral gray; that is, not a gray that is closer in hue to one of the colors used to mix it, but one that falls truly in the middle. This magical proportion is something to be strived for through experimentation—there is no formula. You can also gray your colors by adding already mixed neutrals.

Purity
Any color uncontaminated by other colors is pure. For instance, a pure red (uncontaminated) mixed with a pure yellow will produce a pure orange.

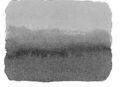

Grayability
Adding blue, the complement of orange, will contaminate or gray the pure orange color. Adding already mixed grays, browns or other neutral colors will also gray the original color.

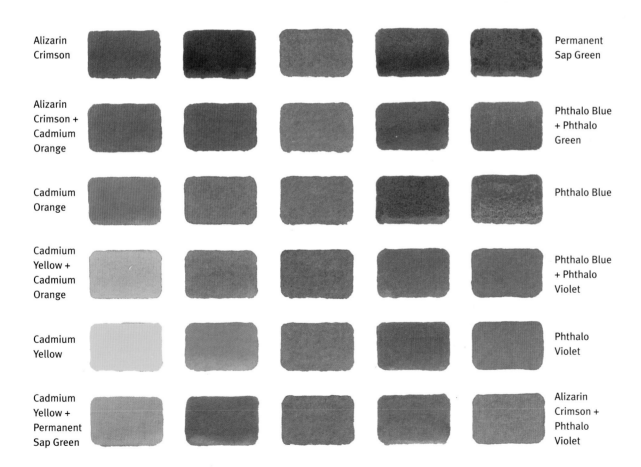

Alizarin Crimson					Permanent Sap Green
Alizarin Crimson + Cadmium Orange					Phthalo Blue + Phthalo Green
Cadmium Orange					Phthalo Blue
Cadmium Yellow + Cadmium Orange					Phthalo Blue + Phthalo Violet
Cadmium Yellow					Phthalo Violet
Cadmium Yellow + Permanent Sap Green					Alizarin Crimson + Phthalo Violet

Mixing Grays

This chart shows the primary, secondary and tertiary colors opposite their complements. A neutral gray has been established at the center point with a slightly grayed color placed between the pure color and neutral gray. A full range of grayed colors can be imagined between the pure color and the neutral gray. It is simply a matter of degree.

TEMPERATURE

Color *temperature* refers to the coolness or warmness of a color. Blue, green and violet are typically recognized as cool colors, while red, orange and yellow are traditionally thought of as warm colors. Cool-colored objects seem to recede in a painting, or appear as though they are in the distance. As such, objects that you want to appear farther away from the viewer, such as distant mountains, should get cooler and grayer as they recede. Warm-colored objects tend to advance or come forward in your paintings.

Paint objects that you want to appear in the foreground using warm colors.

Color temperature is also relative, or judged based on its relationship with surrounding colors. This means that cool colors have warm variations, and warm colors have cool variations. For instance, red-yellow is warmer than red-violet, which contains a good deal of the cool color blue. So, red-violet is seen as a cool color when compared to red-yellow. A general rule of thumb: those colors mixed with a strong

amount of yellow are usually warmer, while those mixed with a generous amount of blue are cooler.

As an artist, you have choices to make as to when to cool down or warm up your paintings. For example, you can cool the shadows within your paintings using blues and violets or warm the shadows with yellows and reddish browns, creating an altogether different atmosphere. Remember, though, to choose colors that will help you achieve desired effects and create a fitting mood.

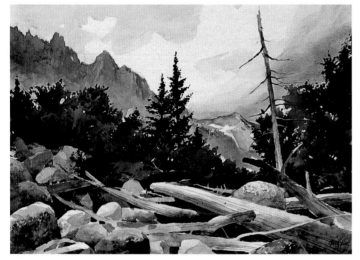

Using Cool Colors in Your Paintings
The mood of this mountain scene is clearly on the cool side. The sky and distant mountains were cooled with blues and violets, the trees were painted predominantly using cool greens and blues in the shadows, and the foreground rocks and logs have touches of blue and violet as well. Using cool colors helped create the sense of depth and recession needed for this painting. Hints of warm color were added for balance and don't take away from the dominance of the cool color scheme.

FALLEN TIMBER
15" X 20" (38CM X 51CM)

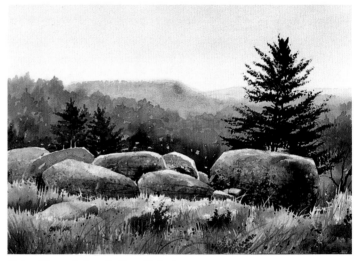

Using Warm Colors in Your Paintings
To paint this warm autumn scene, I used various reds, oranges, yellows and browns in the foliage and grass. I took a few liberties with the rocks, making them warmer than they really were. The greens used in the evergreen trees are also warm.

AUTUMN'S ARRIVAL
15" X 20" (38CM X 51CM)

THE PUSH-PULL EFFECT

Using both cool and warm colors to paint an object creates an interesting effect in your paintings. For example, a maple tree just starting to turn in autumn will have both red and green leaves. This visual contradiction, with the cool greens receding and the warm reds advancing, creates a push-pull illusion within the tree.

VALUE

Value indicates the lightness or darkness of a color. Though an infinite range of values exist, artists refer to the values in their sketches and paintings as light values, middle values and dark values.

When dealing with grays, white is the lightest value and black is the darkest value, with numerous shades of gray in between. Colors also range in value according to the degree of darkness they maintain. High-value colors (light) are sometimes referred to as *tints*, while low-value colors (dark) are also known as *shades*.

Achieving proper value within your paintings is an important element in the design process. Gradations of value in your compositions can help create form and the illusion of depth. Extreme and harsh value changes or jumps can destroy the unity of your composition, but using harmonious values will allow the viewer to see the painting as a whole. Making a value sketch before you begin painting will help you achieve unified values within your paintings.

Value Sketches
A helpful tool in painting is to make value sketches in graphite pencil before starting your painting. These are small black-and-white sketches roughly 4" x 6" (10cm x 15cm) in size. Using such sketches as references will help you get the right values while painting. This is further discussed in chapter 5.

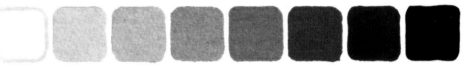

The Gray Scale
This gray scale begins with white, followed by six graduated steps of gray, and ends with a virtual black on the opposite end.

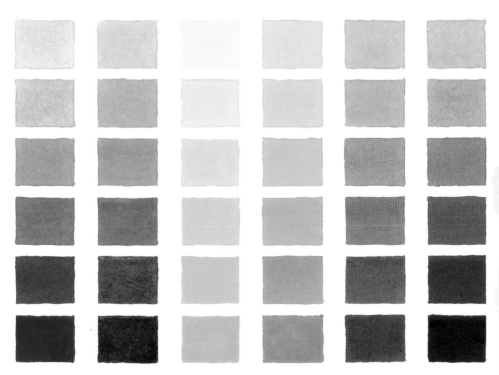

Color Values
Each color on the spectrum has light, middle and dark values. This chart illustrates the value gradation of each primary and secondary color, starting with the lightest values and gradually increasing to the darkest values.

PLANNING VALUES

When planning your values, keep it simple: use your squinters! Regardless of what your mother says, squinting is good for the artist. Squinting at your subject simplifies the value relationships in your composition. It causes the more subtle values to drop out, only retaining those of greater contrast.

KEY

In the art world, the term *key* refers to the overall value of a painting. If a composition is said to be *low-key*, it is dominated by a dark range of colors and contrasted by lights. *High-key* paintings, on the other hand, are predominantly light in value, with subtle middle values and few darks.

Low-Key Painting

The strong contrasts and dark dominance of low-key paintings demand the viewer's attention. Low-key painting is often used to inspire a dramatic, somber or intense mood. There is often a strong use of shadow in low-key paintings, obscuring detail in these areas of darkness. The lighter values or highlights in a low-key painting generally represent the direction of the light source.

The paintings on this page are examples of low-key compositions. The sketches accompanying the paintings show the transition from black and white to color.

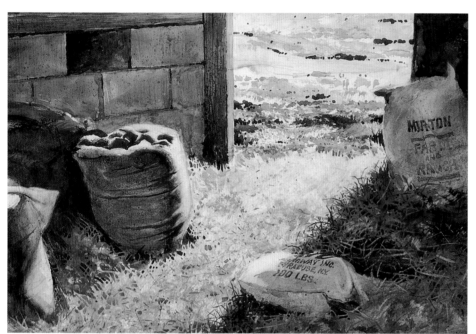

Create Drama With Strong Contrast
In this low-key painting, the indirect sunlight coming through the doorway contrasts the dark values found in the shadows, creating a sense of drama within the composition.

FEEDSACKS
15" X 20" (38CM X 51CM)

Dominant Darks Help Emphasize Lights
Dark dominance is evident in the minimal amount of detail visible in the water and trees in the background, both of which fall in the shadows. These shadows help punch out the lighter values, which represent the light source reflecting off the water's surface.

A DAY AT THE DOCK
15" X 20" (38CM X 51CM)

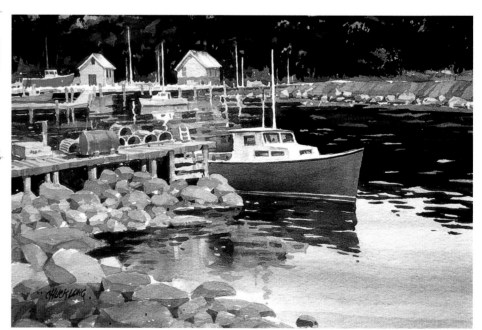

High-Key Painting

High-key compositions are dominated by light values. Though moderate middle values are present in high-key paintings, darks are seldom used.

Unlike low-key paintings, which command your eye with their tension and drama, high-key paintings draw your interest by expressing a sense of calmness and serenity. They evoke a soft, restful and relaxing mood. Often portraying foggy or misty landscapes, high-key paintings can seem almost ethereal or mysterious.

The paintings on this page are examples of high-key compositions.

Again, I have included the value sketches to show how the value and key of the pieces were planned before painting.

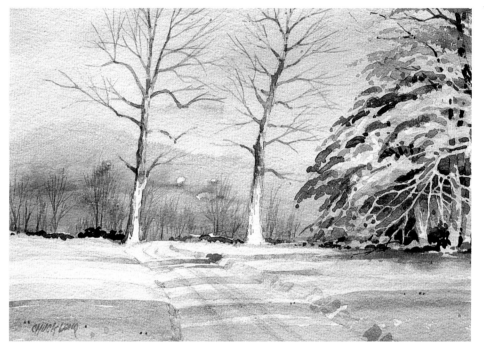

Evoke The Calmness of a Cold Day
Light values in this high-key painting help communicate the stillness in the air of a winter day.

DEAD OF WINTER
15" X 20" (38CM X 51CM)

A Lack of Dark Values Suggests Mystery
Fog rising off the water is characteristic of high-key paintings and contributes to the mysterious feel of this composition. Notice that the only dark values present are the shadows beneath the dock.

A VILLAGE IN THE MIST
15" X 20" (38CM X 51CM)

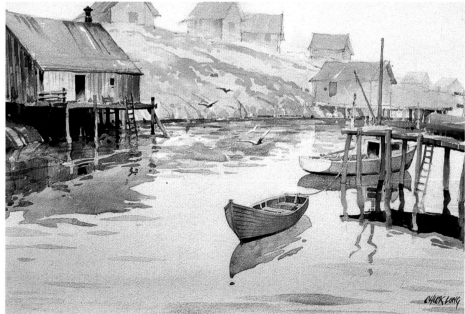

GRANULATION

On several occasions students have come to me exclaiming that there was something wrong with their paints because they "looked funny." Curious to see what they were talking about, I examined their "funny paintings." To my delight and theirs, I pointed out that nothing was wrong with their paintings; rather, they were just noticing the effects created by *granulation*, one of the most wonderful occurrences in watercolor.

Granulation is a property of certain sedimentary pigments whose heavy particles settle into the hollows of the paper. When the particles of these paints sink and settle at the bottom of the paper's textural pits and valleys, a grainy appearance results.

Using granulating pigments can add a sense of texture to your compositions. Ultramarine Blue is probably the biggest contributor to this effect, although earth colors are also granulating.

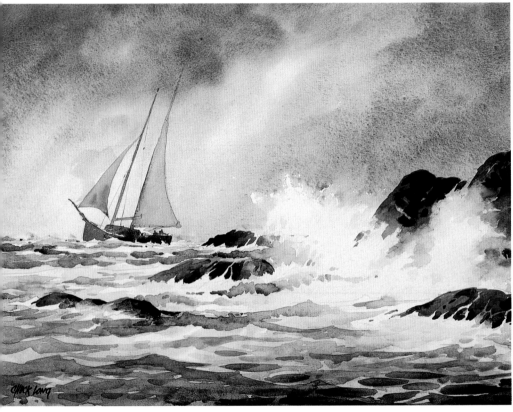

Using Granulation to Enhance Mood
Granulation is most evident in the sky of this maritime painting. The separating of some of the colors combined with this grainy effect adds to the stormy and dramatic mood of the painting. The contrast between the grainy background and the smoother water and wave action also add depth to the picture.

CRASHING WAVES
15" X 20" (38CM X 51CM)

Granulation in Action
Ultramarine Blue is a great example of a granulating color. Even when mixed with other colors, it can retain its granulating power. In the top panel Ultramarine Blue was added to Olive Green, while the bottom panel shows a mixture of Alizarin Crimson, Cadmium Yellow Medium and Ultramarine Blue. Notice in both examples how the heavy pigment particles of Ultramarine Blue separate and settle into the texture of the paper, creating a wonderful grainy effect.

PERMANENCE

Permanence, or lightfastness, refers to a paint's ability to resist fading when exposed to light. The permanence of any particular paint is rated on a scale that ranges from excellent (will not fade) to fugitive (will fade). Professional paints are often labeled Category I (excellent), Category II (good) or Category III (moderate) for the artist's shopping convenience. Other brands may have a rating of AA for excellent, A for very good, B for good and so forth.

Lightfastness in your selection of paints is very important. The permanence rating of the paints you buy determines the longevity of your paintings, so think permanent. I recommend that you use only those colors with a rating of good to excellent. Stay away from pigments rated fair or moderate, as they will fade with time. In some cases, moderate or fugitive pigments will show considerable fading after only a short time, especially if they have been exposed to sunlight or other strong light sources.

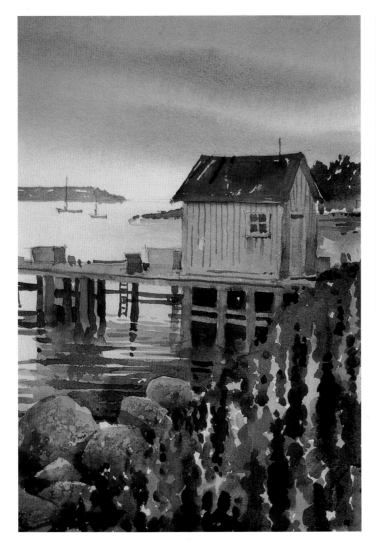

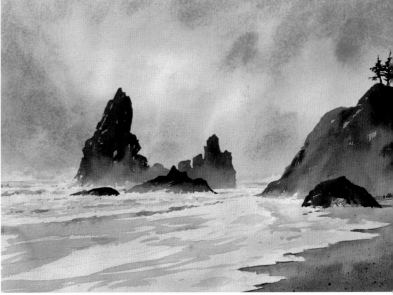

Permanent Colors Yield Permanent Results
Both of these paintings, though several years old, show no evidence of fading. This is due to using quality paints with good permanence ratings. The permanence of colors can make all the difference if you want to preserve your paintings and help them maintain their original beauty, so be sure to read labels!

PROTECT YOUR PAINTINGS

Never expose your watercolor paintings to direct sunlight for any length of time, even if you use pigments rated as excellent in permanence. There is no recapturing a fugitive color once it has fled.

TRANSPARENCY vs. OPACITY

In order to make the right color choices for your paintings, you must understand the properties of *transparency* and *opacity*. These two terms deal with how much light is able to penetrate a color. Most watercolor paints are either transparent or semitransparent. By definition, a transparent paint allows light to penetrate through its surface to the underlying paper. The light then bounces off of the white paper, creating brilliant color effects. Some good examples of transparent colors include Alizarin Crimson and Phthalo Blue.

The opposite of transparent, opaque paints allow very little light to penetrate their surface, drastically minimizing the light bounce from the paper. Very few watercolors, with the exception of white, are fully opaque. When watercolorists refer to paints that are fully opaque, they are usually speaking of other water soluble mediums like gouache or tempera. Actual colors (for instance, Cadmium Orange and Cadmium Yellow) are referred to as

opaque if they are difficult to see through or don't work well in layering applications.

Both transparent and opaque paints have their strong suits. For example, watercolor techniques such as layering are best accomplished using transparent and semitransparent colors. In doing so, you'll be able to see through the layers and perceive each one individually. On the other hand, opaques and semiopaques have strong covering power and do not work well for layering. However, this strong covering power *does* work well for correcting mistakes or covering undesired passages. I advise you not to rely too heavily on this method of revision, though, as opaques can take away from the resplendency of your painting. Try getting your colors and values right using transparent and semitransparent paints whenever possible. Use opaques to cover mistakes only as a last resort.

The Transparency/Opacity Test
If you're uncertain as to which of your paints are transparent and which are opaque, simply test them. Draw a few dark lines on scrap paper and paint swatches of any color over these lines. In this illustration, Phthalo Blue is on the top and Cerulean Blue on the bottom. Notice my pencil lines are visible beneath the Phthalo Blue, meaning it is transparent, but they are nearly invisible beneath the Cerulean Blue, meaning it is a semiopaque.

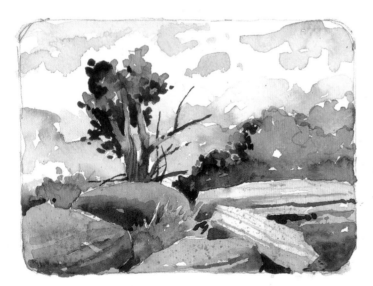

Transparent Paints
This rocky landscape was painted using Alizarin Crimson, Phthalo Blue, Phthalo Green and Phthalo Violet, all of which are transparent colors. Being able to examine each individual layer where color and value have been built up lends to a sense of dimension.

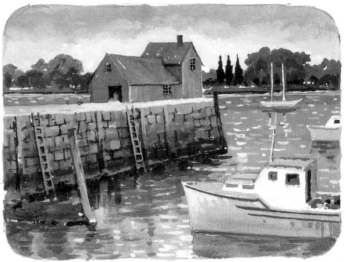

Opaque Paints
In this example I mixed an opaque white with my watercolors instead of adding water to lighten. Notice the darks have little or no opaque white added; these colors are already fairly opaque because of their density.

STAINING vs. SEDIMENTARY

Staining colors, as the name implies, will stain or dye everything that they touch. These pigments absorb deeply into the fibers of your paper, strongly resisting any efforts to lift out color. Usually very transparent, staining colors are good mixers and produce clean colors that can be used for laying down layers. Phthalo colors are among the strongest of the stainers, joined by greens and alizarins.

Conversely, *sedimentary* colors lay on the surface (as a sediment) and do not absorb into the fibers of your paper. As a result, these pigments lift out easily, allowing you to create light areas within a darker area. This is done by simply rewetting an area and blotting it with a tissue or paper towel.

Sedimentary colors tend to be more opaque than staining colors. They can also produce mud if used to paint layers, as they lift off the surface when re-wet and mix with the fresh layers placed over them. You have to work carefully and quickly to keep your sedimentary paints clean and fresh. It takes practice. Some examples of sedimentary colors are Ultramarine Blue, Burnt Sienna, cadmiums and all earth colors. If handled properly, they can produce marvelous color combinations.

DRESS FOR THE OCCASION

Take heed when painting with staining colors. Though they don't really damage your brushes or palette, they can ruin your clothes, and these stains never come out!

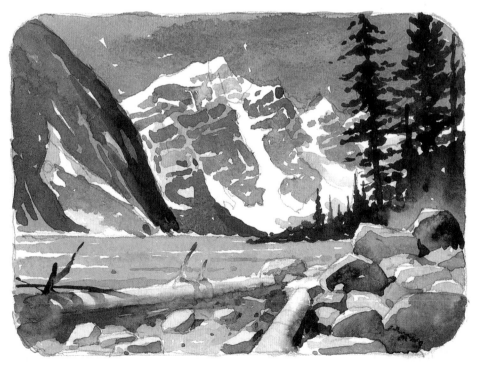

Staining Colors
I used staining colors in this illustration to capture the brilliancy of the sunlit flowers and foliage. The transparent and luminous nature of staining colors works perfectly for depicting such subject matter.

Sedimentary Colors
I used the sedimentary colors Ultramarine Blue and Burnt Sienna as my base colors for this illustration. Because sedimentary colors do not absorb into the paper fiber, I was able to lift out color. This is particularly helpful if you want to create light areas within a darker area of your painting.

COLOR SELECTION

Now that you have a basic understanding of paint properties, you're ready to select colors for your palette. But where do you begin? The chart below displays a variety of popular colors and their essential properties. Review this chart before shopping to get an idea of a color's temperature, staining ability, mixing capabilities and more. Notice I have used overlapping color swatches to demonstrate the effect each color will create when used for layering. As you can see, the more transparent the color, the greater the effect will be. Keep this and all other factors in mind when selecting paints. The more you know about your colors, the more successful your paintings will be!

BURNT SIENNA
Very warm, sedimentary brown; mixes well, especially with Ultramarine Blue.

BROWN MADDER
Warm, transparent, staining reddish brown; mixes well, especially with Ultramarine Blue.

ALIZARIN CRIMSON
Somewhat cool, very transparent, staining red; is a good mixer.

CADMIUM RED
Very warm, opaque, sedimentary red; doesn't mix well with all colors and lifts out easily.

CADMIUM ORANGE
Warm, very opaque, sedimentary orange; mixes moderately well with lifting-out capability.

CADMIUM YELLOW
Warm, opaque yellow; a good mixer and lifter. Be careful: it can become overpowering.

PERMANENT SAP GREEN
Warm, transparent, very staining green; a good mixer for all sorts of foliage.

PHTHALO GREEN
Cool, very transparent, very staining green; mixes well and grays nicely with Alizarin Crimson.

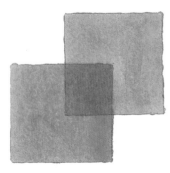

CERULEAN BLUE
Cool, semitransparent, sedimentary blue.

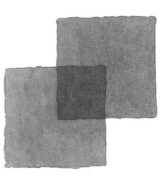

PHTHALO BLUE
Cool, very transparent, staining blue; mixes well with other colors.

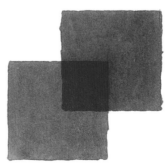

ULTRAMARINE BLUE
Warm, semitransparent, sedimentary blue; mixes very well with other colors.

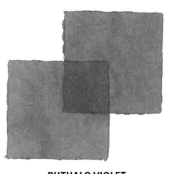

PHTHALO VIOLET
Very transparent, somewhat staining violet; good mixing color that can be considered warm or cool, depending on the colors surrounding it.

COLOR COMBINATIONS

Sure, it's important to choose colors that you like for your palette, but in order to create the most successful painting, you also need to consider which colors work well together. The color combinations displayed on the following pages are what I call my "workhorse colors," or those colors that I use in almost every painting. These colors combine with each other in an infinite number of ways, creating exceptional, harmonious colors. They also mix to produce a variety of neutrals, including grays, browns and blacks. The possibilities as to what you can paint with these color combinations are limitless! Experiment with these combinations and others to find what works well for you.

Ultramarine Blue, Alizarin Crimson and Burnt Sienna
These colors are among my favorite workhorses. Ultramarine Blue and Burnt Sienna were meant for each other, and adding Alizarin Crimson just sweetens the pot. The blue is cool, and the brown and red are warm. They can produce cool, neutral and warm variations of gray, rich and transitory. This mixture can start out as a cool blue, move smoothly into a cool gray and finally end up as a warm brown. Lovely violets are produced as well. Expect some granulation.

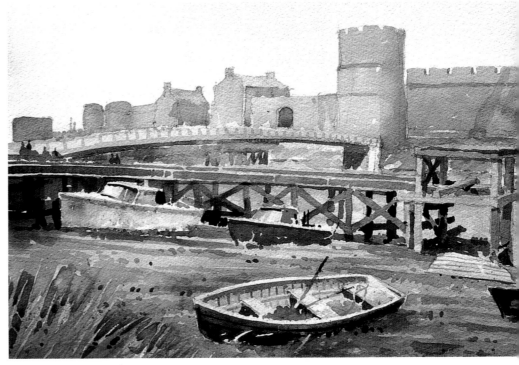

Great Grays Create a Moody Scene
This painting was built using the aforementioned workhorse colors, making the great grays and browns in this moody Welch scene. Other colors, such as Cadmium Yellow Medium and Cerulean Blue, were used lightly and subtly for interest.

CAERNARFON HARBOR
15" X 20" (38CM X 51CM)

Cerulean Blue, Phthalo Violet and Raw Sienna

There is enough of the three primary colors in this combination to give a great variety of grays, both cool and warm. The result is rich, earthy browns against cool blue skies with warm or cool violet shadows.

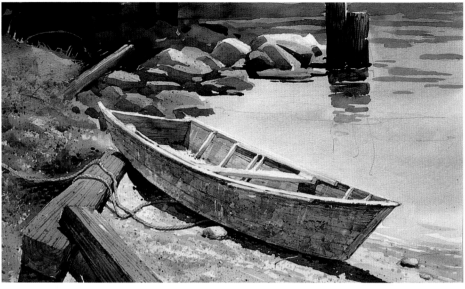

Richness in Earth Colors and Textures

The painting of the boat and rocks shown here illustrates much of the richness created by this color combination. The Cerulean Blue and Raw Sienna work particularly well together, helping depict the earthy textures and capture the rough, rustic mood of the piece. Phthalo Violet further adds to the richness, cooling and deepening the shadows.

BOAT, DEBRIS AND ROCKS
15" X 20" (38CM X 51CM)

Permanent Sap Green, Brown Madder and Cerulean Blue

Sap Green is a terrific foliage green and grays nicely when mixed with Brown Madder, a color which contains green's complement, red. Cerulean Blue is a nice cooling agent for the other warm colors in this combination. The possibilities are endless. The lighthouse shown here is a good example of these colors performing well.

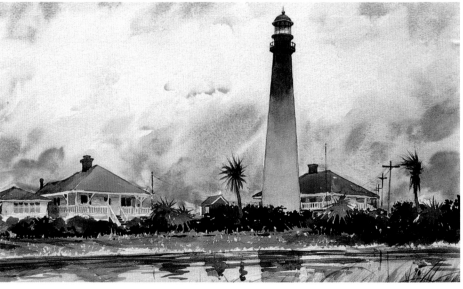

The Unifying Effect of One Color

Oftentimes one color can pull all the others together, creating a sense of unity. Brown Madder is the amalgamator in this painting, graying the blues in the sky and the buildings, and subduing the greens in the grass and trees. By simply adding Brown Matter to the other colors, it has helped tie all of the elements in this painting (including the solid Brown Matter roofs) together.

A TEXAS LIGHTHOUSE
15" X 20" (38CM X 51CM)

Burnt Sienna, Yellow Ochre and Ultramarine Blue

Here is another marvelous combination that features Ultramarine Blue and Burnt Sienna. This time we have Yellow Ochre as the representative for additional warmth. Glowing golds, rich rust and cool shadows in a gray world of decay might describe the accompanying painting, which uses a good amount of these colors.

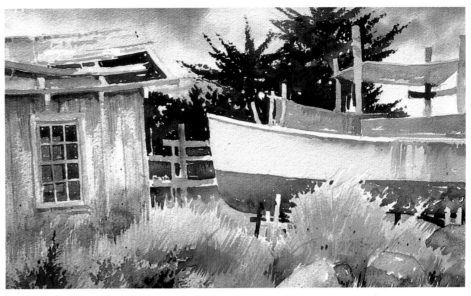

Experiencing a Full Range of Grays

Burnt Sienna and Ultramarine Blue always produce marvelous results when used together. The spectrum of grays created by mixing these two colors is incredible, ranging from a grayed cool blue to a warm grayed brown and countless shades of gray in between. These various grays are seen in almost every object in this painting, including the wood and rocks. The addition of Yellow Ochre balances these beautiful grays and gives a warm feeling of sunshine.

BOAT AND SHACK
15" X 20" (38CM X 51CM)

Alizarin Crimson, Cadmium Yellow and Phthalo Blue

These three colors mix extremely well together. They are the three primary colors from which I have my students derive every other color in the visible spectrum (and some of those that aren't in the spectrum!). Every gray, brown and even a virtual black can be made from these colors.

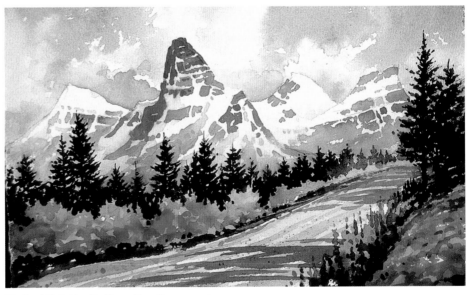

Limited Palette, Endless Results

This is the basic red, yellow and blue combination with which you can make any color. A wide range has been created here, from cool to warm and light to dark. Vivid color abounds when using these workhorse colors, and the white of the paper makes it all sparkle.

ROAD TO THE MOUNTAINS
15" X 20" (38CM X 51CM)

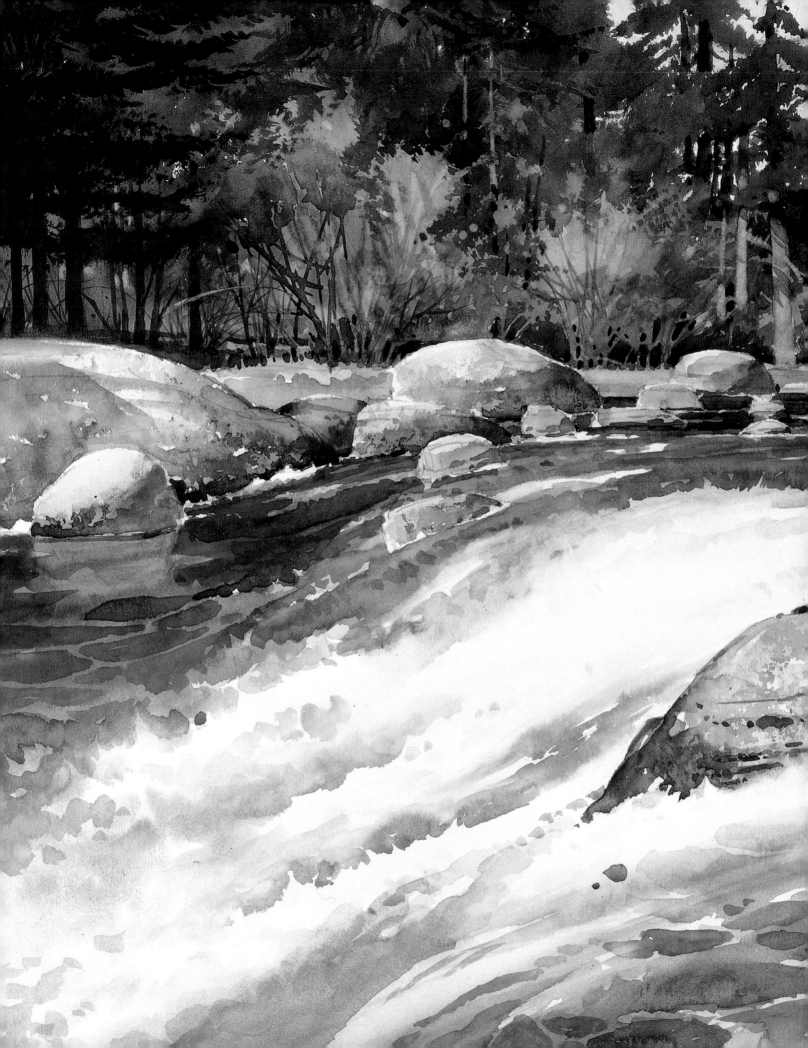

3 DESIGN ELEMENTS & PRINCIPLES

CHATTOOGA RIVER
22" X 30" (56CM X 76CM)

SHAPE

To understand the process behind creating a successful design, you must first possess a working knowledge of the *elements of design*, or the rudimentary components an artist uses to create a painting. Chapter 2 provided you with a close look at color and value, two of the five essential elements of design. The next few pages will discuss the three remaining elements that I find essential to good design—shape, form and texture.

Shape refers to any two-dimensional object. When you think of shapes, common geometric forms such as circles, squares, triangles and polygons probably come to mind. However, shape can also refer to the overall silhouette of an object. For example, the silhouette of a car, even though it consists of a series of angles, curves and more complex lines, can still be painted or drawn as a two-dimensional shape. Additionally, shape in painting deals with both positive and negative spaces, as well as indeterminate masses known as amorphous shapes.

Shape alone often provides instant recognition of an object. Certainly the profile of a person's head, a teapot or a boat are recognizable. However, understanding shape is merely one piece of the design puzzle, as shape defines only part of an object's identity. In order to portray realistic objects accurately, you will need to add form and texture to the shapes in your paintings. These three elements together, along with color and value, give the artist the ability to depict any object.

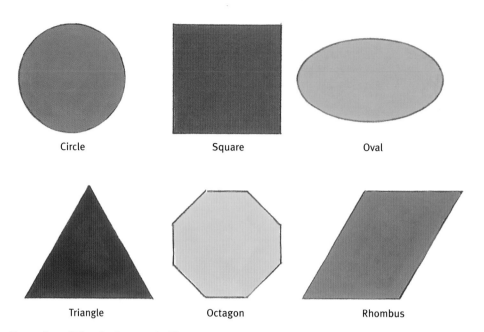

Examples of Simple Geometric Shapes

Circle Square Oval

Triangle Octagon Rhombus

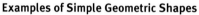

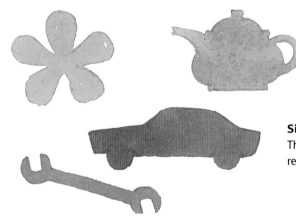

Silhouettes
These everyday objects are easily recognizable by their silhouettes.

Positive and Negative Space
Not all shapes and silhouettes are solid, nor do they all have clean and simple lines. Some shapes, like this tree, are made up of a series of positive and negative spaces. The strokes of paint indicating foliage are *positive spaces*, or the actual objects. The small, unpainted areas between the foliage constitute *negative spaces*, or those spaces around objects.

FORM

Another element of design, *form* is the three-dimensional quality given to shapes by suggesting patterns of light and shadow. Forms differ from shapes in that they enclose volume, creating the illusion of depth.

Any simple geometric shape can be drawn or painted as a three-dimensional form. For example, a two-dimensional circle can easily be turned into a sphere by appropriately placing highlights, reflected light, form shadows and cast shadows on or around the circle. In particular, you would place the highlight at the point on the sphere where the light most directly strikes the object. From that point, a light area around the highlight should gradually decrease in intensity and get slightly darker in both directions. When the lighted area rounds away from the light source, a shadow should begin to form. This shadow should gradually darken until it reaches its darkest point and encompasses the remainder of the backside of the object. Voila! With just a few quick steps, you've transformed a circle into a sphere!

As previously mentioned, any two-dimensional shape can be depicted as a three-dimensional form. You can also achieve complex forms using geometric forms as your base. In fact, almost every object can be created from simple forms, either in whole, part or combination with each other. For instance, a tree trunk is a cylinder, an urn is a combination of a cylinder and a sphere, and the walls of a house are cubic or box-like, while the roof is similar to a pyramid.

SPHERE — Form Shadow, Highlight, Cast Shadow, Reflected Light

CYLINDER — Form Shadow, Highlight, Cast Shadow, Reflected Light

URN — Form Shadow, Highlight, Cast Shadow, Reflected Light

Simple Geometric Forms

THE LANGUAGE OF LIGHT

Simple shapes are turned into three-dimensional forms through the use of light and shadow. Use the following definitions to help you better utilize these elements to create forms within your paintings.

Cast Shadows: shadows that are cast or thrown from an object. Primary light sources shine in a straight line until they encounter shapes or objects. Being interrupted in its path, the light will cast or throw a shadow from the object onto the next plane or object it encounters.

Form Shadows: shadows that are formed on the object itself, created by the shape of the object as it is struck by light.

Reflected Light: light which has passed around a lighted object and bounces off other planes or objects. This light is then reflected back into the form shadows, becoming, in effect, a weaker secondary light source.

Highlight: the reflection of a light source being bounced off a somewhat glossy object in your painting. The location of a highlight is directly related to the angle of the light source.

FORM CONTINUED

The painting on this page illustrates just how light and shadow work together to transform what might otherwise appear as flat, two-dimensional silhouettes into three-dimensional forms. The primary light source, interrupted by the objects, creates cast shadows. The darker, harder edges are closest to the objects and lessen in intensity as they get farther away. Because light can only hit several planes of an object at once, form shadows develop on the objects. These shadows begin subtly, gradually getting darker until they reach the darkest point in the formed shadow. The reflected light then partially lightens the darkest portions of the form shadows, adding vibrancy and color to these dull areas. Finally, the highlights help indicate the reflective nature of the objects as well as the direction of the light source, which in this case is coming from the front.

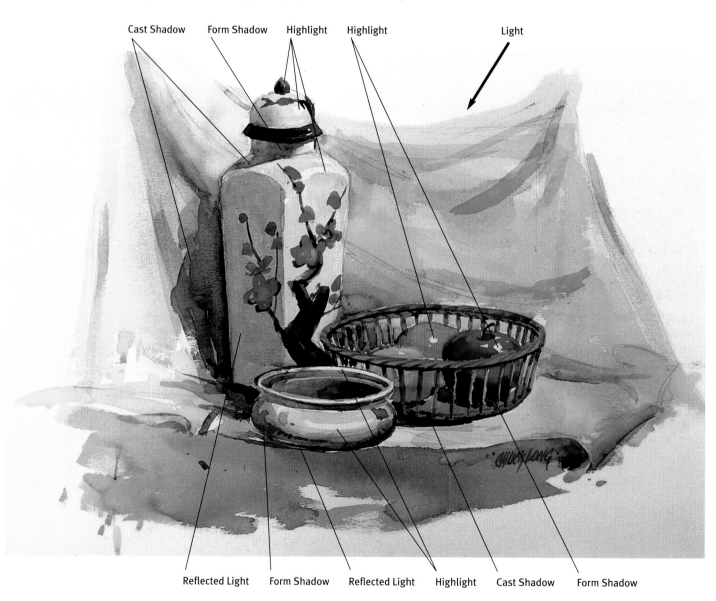

Cast Shadow · Form Shadow · Highlight · Highlight · Light

Reflected Light · Form Shadow · Reflected Light · Highlight · Cast Shadow · Form Shadow

A STILL LIFE WITH CHINA AND FRUIT
13" X 18" (33CM X 46CM)

TEXTURE

Generally we think of *texture*, the last element of design, as something we can feel as our fingers run across a surface. For instance, when we touch tree bark, our senses tell us we are encountering a rough texture. On the other hand, a piece of sheet metal will feel smooth and polished to our fingers. In physically examining an object with our sense of touch, we are experiencing the object's actual texture. In art, however, there is also an implied visual texture that can't be felt with the fingers. These simulated textures are suggested by the artist through the use of painting techniques. For example, the spattering technique can make rocks or wood grain appear rough in texture and thus more realistic. By employing the techniques discussed in chapter 4, you will be able emulate any texture you desire.

In order to achieve successful design, it is important for you to view texture as more than the roughness or smoothness of an object. Specifically, depicting texture requires the artist to recognize the innate characteristics and patterns in objects, whether natural or man-made. Natural textured patterns might include the grid on a turtle's shell or the style of a person's hair, while man-made textural patterns could include the creases and folds of a person's clothing. Each of these examples requires the painter to carefully observe the relationships between shape, form, light and shadow in order to accurately render texture. As a general rule of thumb, paint form first and then add texture. You will find this formula to be simple, quick and effective.

Natural Textures
Both the tree bark and the rock wall illustrated here were painted with my "form first, then texture" formula. Paying careful attention to the patterns present in these objects helped give them a more dynamic and realistic texture.

Man-Made Textures
Like the tree bark and rock, the tablecloth was painted by showing form first and then adding texture to suggest the folds and drapes of the cloth. Attempting to simulate man-made texture of objects such as bricks and shingles, though, requires more planning and attention to details like proportion and perspective (see chapter 5 for more on perspective).

BALANCE

Now that you're familiar with the essential elements of design, you're ready to take the next step toward constructing a strong composition: learning how to arrange these elements in the most visually appealing manner possible. Applying the *principles of design*, or those concepts used to organize the elements of design in a composition, is the best way to ensure a solid arrangement.

One of the most important principles of design is *balance*, or the harmonious positioning and proportioning of elements. A visual sense of balance is achieved by placing objects in such a way that they are equalized by other objects in the painting. Such placement ensures that one side of the composition does not outweigh the other or disturb the aesthetic value of the painting as a whole. If all objects are placed to either the left or right and are off balance within the borders of your painting surface, the viewer's eye will be forced to that side. With no objects of equal interest on the other side of the composition, the eye will then exit the painting. Thus, when you place an object of significant size, mass or volume on one side of your composition, place additional objects on the opposing side to balance out the composition and hold the viewer's interest.

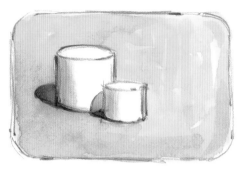

Poor Balance
With nothing on the right to equalize the heavy object on the left, this composition lacks balance, ultimately hurting the overall design.

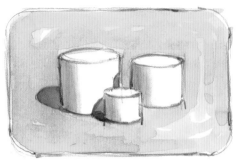

Strong Balance
By simply adding an object to the right, the balance of this composition is corrected.

Attention to Placement Leads to Balance
Here we have three objects, positioned and proportioned so as to make a well-balanced composition. Neither side of the painting is heavier than the other, and all of the objects equalize one another, resulting in strong balance.

MILK CAN, APPLE AND BASKET
15" X 20" (38CM X 51CM)

RHYTHM

Often equated to movement, *rhythm* is the design principle most responsible for creating a clear path that the viewer's eye can follow. Just as music relies on a recurring beat or rhythm to carry the listener through a song, paintings depend on rhythm to lead the viewer's eye throughout a composition. Employing patterns in your paintings is a great way to suggest rhythm. The repetition of lines, shapes, colors and values can help you achieve a strong sense of rhythm in your paintings. Doing so not only guarantees a clear visual path for the viewer, but also establishes order and predictability within a composition, providing the viewer with a sense of comfort.

Poor Rhythm
The lack of movement and repetition in this composition fails to create a strong visual path, making the design static and flat.

Strong Rhythm
In this example, movement and repetition of shape and color create rhythm. However, notice that the repeated objects (rocks) are not exactly the same. I alternated the sizes of the rocks to maintain variety and interest.

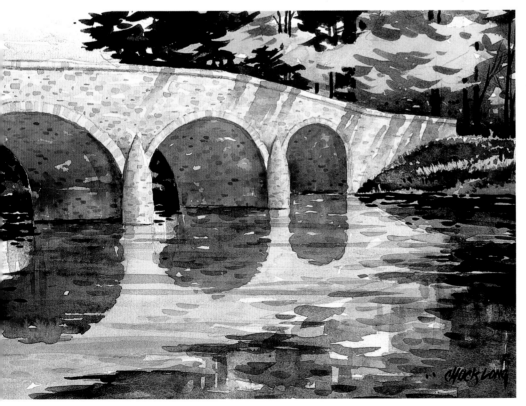

Repetition Creates Rhythm
The repetitive movement in the arches of this bridge give the composition rhythm, carrying the viewer's eye along a connected and predictable path.

ANTIETAM BRIDGE
15" X 20" (38CM X 51CM)

DOMINANCE

To emphasize the element or elements of your painting that are most valuable to the telling of the story, you must utilize *dominance*. This design principle stresses the most important features of your painting, drawing attention to one or more points within a composition by means of contrast. This contrast may be difference in size, shape, line direction, position, value or color. For example, the dominant element may be larger than other parts of the painting or it may have an unusual shape. Similarly, the dominant value may be lighter or darker than those surrounding it, while the dominant color may be more brilliant in hue compared to other colors in the composition.

When designing your composition, use dominance to make the viewer look at the *focal point*, or the most important element within your painting. The focal point is the object or area of a painting that functions as the center of interest. As such, it should be the first element to catch the viewer's attention. Surrounding elements should support the focal point and be placed in such a way that they lead the viewer through the picture and to the center of interest.

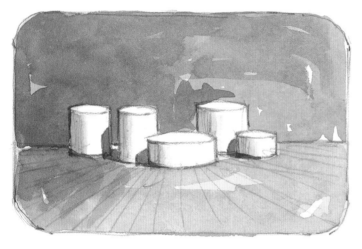

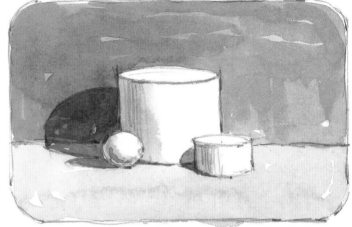

Poor Dominance
Because the elements in this example are too similar in shape and size, none of the objects particularly grabs the viewer's attention. Without noted contrast there is no dominance.

Strong Dominance
The center object in this example clearly dominates the composition. Placement and contrast of size help to emphasize this object and set it apart from the others.

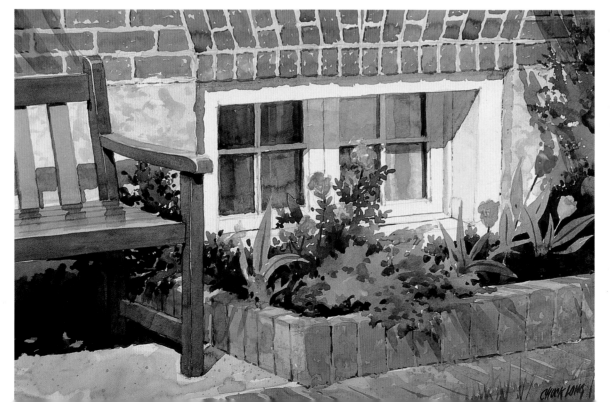

Color Captivates the Viewer
The vividly pure colors of the flowers in this painting pull your eye into the composition. The dominance of the blossoms clearly illustrates how you can use color to emphasize an area of your painting.

BARNSLEY GARDENS
15" X 22"
(38CM X 56CM)

HARMONY

Another design principle you'll need to consider when arranging elements within your composition is *harmony*, or the presence of compatible components that combine to create a unified whole. By choosing elements that relate to or complement each other, you can easily accomplish a harmonious design. This doesn't mean that contrast should be avoided. As you already know, contrast is an important way to create emphasis or dominance in your paintings. However, an excessive amount of clashing elements within your design will ultimately lead to a failed composition. Whether it be too much variation in value or color, or too many directions and shapes, a disproportionate use of incongruous elements is guaranteed to destroy the continuity and harmony of your painting. Thus, controlling contrast in your compositions will help to ensure that all elements are in agreement with each other. Try using repeating shapes, analogous or complementary color schemes, similar values and tones, or a dominant line direction to create harmony in your design.

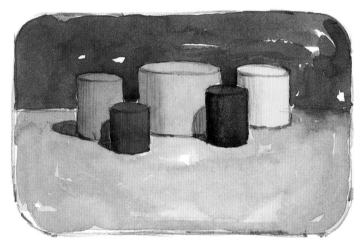

Poor Harmony
Though the repeated cylindrical shape creates some sense of continuity, the elements in this grouping clash in both color and value, resulting in an inharmonious composition.

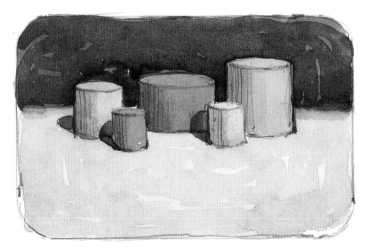

Strong Harmony
The colors and tones used in this composition work well together, possessing just enough contrast to establish dominance without destroying harmony.

Keep It Related
Notice that the colors used for this painting are both predominantly warm and analogous. By using colors that are related, a sense of harmony has been established. The fact that the composition consists of mostly vertical lines further enhances the harmony, helping tie the elements of the painting together.

MOUNTAIN ROCKS AND TREES
20" X 15" (51CM X 38CM)

LEGIBILITY

When examining a realistic, objective painting, the viewer should be able to decipher the objects and comprehend the scene. In other words, the painting should possess *legibility*. Though many artists may not consider legibility to be an imperative design principle, I find that it is essential in creating a successful composition. After all, if you arrange your design elements in such a way that the scene is difficult to read, the viewer is likely to lose interest. If you want to keep your audience captive, I recommend considering legibility when laying out your design.

There are several mistakes that can affect the legibility of a scene. For example, an extreme close-up of an object often loses meaning, as the viewer is unable to recognize elements at such a close range. In cases like this, you can improve legibility simply by painting from a farther distance. This enables the viewer to examine the object in its entirety, making it more decipherable. It also places the object in an understandable context, allowing the viewer to examine the object's relationship with the background, foreground and other surrounding objects. Another mistake that can destroy legibility is to make your design so busy that the viewer is unable to distinguish individual shapes and forms. If this problem arises, try simplifying your composition by removing all unessential objects from the scene.

Poor Legibility
Painting this barn from such a close perspective results in a loss of recognition and legibility. This loss will ultimately lead to the viewer losing interest in the composition altogether.

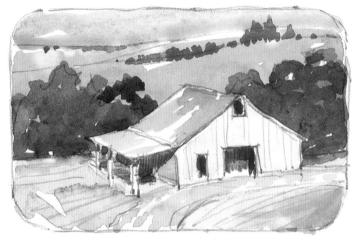

Strong Legibility
By placing the barn in the context of a scene (complete with a background, foreground and aerial perspective), the composition is now legible.

Reasonable Distance Assists Legibility
Had I painted the bridge's entrance at a close range, the viewer would be unable to determine what they were looking at. However, by pulling back and painting the bridge from a reasonable distance, the viewer will have no trouble reading this scene.

**CULLMAN COUNTY
COVERED BRIDGE**
15" X 20" (38CM X 51CM)

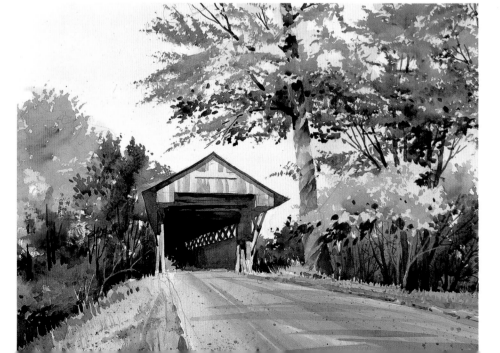

UNITY

Perhaps the most important principle of design, *unity* can be defined as the quality of oneness within your painting. A unified composition is one where all parts come together to form a cohesive unit. All of the various elements must relate to and interact with each other, visually fusing to create a uniform whole.

If individual components aren't connected to each other or are separated by excessive spacing or drastic changes in value and color, disunity results.

Unity is achieved through the employment of other design principles. For example, harmony often acts as a catalyst to unity, creating relationships between individual aspects within a painting and helping them blend together. However, take care to balance harmony with variety in order to avoid monotony. Adding touches of variety to the unified whole ensures visual breaks and creates interest within the composition.

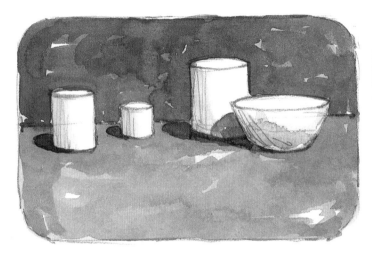

Poor Unity
Bad placement and excessive spacing leads to disunity.

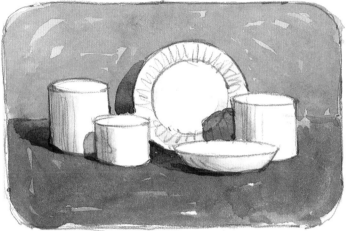

Strong Unity
The visual balance between harmony and variety, as well as the advantageous placement of the objects, creates a strong sense of unity.

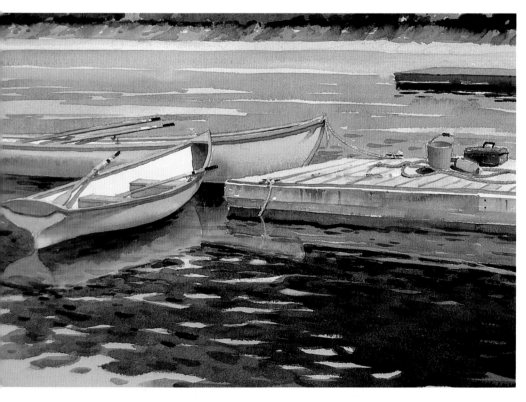

Fusion of Relational Elements Results in Unity
Unity in this painting is accomplished in a variety of ways. For example, the boats and docks overlap each other, interacting to create a cohesive unit. Using a palette of colors that relate to each other (notice the repetition of warm hues) also helps to solidify all of the individual components into a unified whole.

LAKE MCDONALD BOATS
15" X 22" (38CM X 56CM)

PUTTING IT ALL TOGETHER

Possessing a knowledge of the principles of design will certainly help you create a stronger composition. However, knowing how to combine these elements together within a single composition is the key to constructing a successful painting. It is the culmination of these six principles, after all, that will ultimately result in interesting design.

The following list explains how each principle of design was employed to create the painting *Abandoned Alaskan Boat*.

BALANCE The visual scale of this composition is harmoniously proportioned, not appearing heavier on one side or the other. The equalizing of weight and volume results in steady balance.

RHYTHM Here we have repetition and movement within the composed elements (especially in the rocks and trees), creating a clear visual path that leads to the star—the boat.

DOMINANCE There is no contest here—the boat dominates by placement, shape, size, color and value. Everything leads us to this focal point.

HARMONY The overall arrangement of elements within this composition is pleasing. There are no incongruities in the picture—no clashing of color, value, sizes or shapes. All of the elements work together in harmony.

LEGIBILITY There are very few abstract qualities in this painting. Immediate recognition is present in all elements, making the painting readable.

UNITY Each element of the composition fits nicely with the other parts. Everything belongs and contributes nicely to the story.

ABANDONED ALASKAN BOAT
15" X 20" (38CM X 51CM)

52

4

ESSENTIAL
TECHNIQUES

CAMPOBELLO HOUSE
15" X 20" (38CM X 51CM)

WASHES

The primary technique in watercolor painting is laying down *washes*, or large, thin layers of color. Washes can be applied to the entire paper or to smaller designated spaces, but are frequently used to cover broad areas. An important thing to remember when laying down a wash is that watercolor paint should flow out of the brush and onto the paper. It's not like oil painting, where gobs of paint are smeared onto the canvas—watercolor washes should be fluid. This section discusses two common types of washes, flat and graded.

Flat Washes

Flat washes are even and consistent washes with no changes in value, no streaking and no splotching. But just as a sustained musical note can become monotonous after a while, flat washes can become boring. Remember, the key to creating interest in design is *change*, so be careful not to sustain flatness for too long a time. There are, however, times when flatness is the right choice, and knowing the proper technique to create this effect will benefit the artist.

Figure A

Painting a Flat Wash
To produce a flat wash, use a fully loaded brush and touch a bead of paint onto your surface, moving that bead back and forth across the paper. Beginning at the top and working your way down, let the paint flow down the sloping surface. At the end of your wash, squeeze out the brush and pick up any excess wetness at the bottom. Touching the tip of the brush back into the excess (puddle) will pull excess paint back into the brush. This will prevent a blossom (see figure D) from occurring.

Figure B

Consistent Flat Wash
This is a good example of a completed flat wash. Notice how the tone is consistent throughout, as there are no changes in value, no streaking and no splotching.

Figure C

Streaked Wash
The value in this wash is inconsistent or uneven, making it a *streaked wash*, not a flat wash. Notice that the wash changes from a lighter, more transparent value to a darker value, creating a streaked effect.

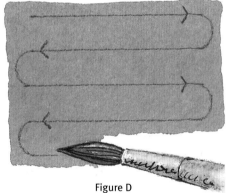

Figure D

Blossoms
A *blossom*, or a *backrun* as it is sometimes called, is not always a bad thing when it occurs in your wash. It gives a feeling of looseness, sketchiness and spontaneity to your painting. There will be times, however, when you won't want this to occur. It is up to you to decide when it is appropriate.

VARIATION EQUALS INTEREST

Use flat washes where necessity dictates, but make changes within your values for interesting design.

Graded Washes

Graded washes are washes that change in value as they are being laid. These washes can start out as a lighter value and gradually become darker or vice versa. Controlling value in watercolor is simple—to make it lighter, add water, and to make it darker, add pigment. When creating good graded washes, I find it easier to go from dark to light. Starting out with a darker value and adding water to your mixture as you go along will lighten the value. The challenge is to make it an even, gradual change without obvious, sudden jumps in value. A gradual change from light to dark is more difficult. Adding pigment as you go along can easily create streaks in your wash. Of course, there are times when a smooth graduation in value doesn't matter, so don't be afraid to try working from light to dark. I suggest that you familiarize yourself with both techniques and work the way that suits you best.

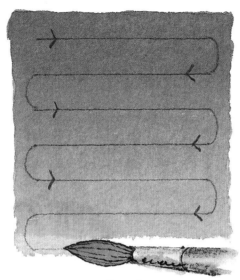

Figure A

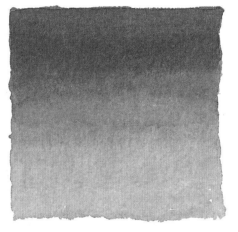

Figure B

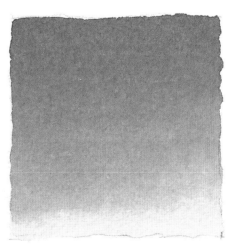

Figure C

Painting a Graded Wash

Painting a graded wash is similar to painting a flat wash. Use a fully loaded brush and touch a bead of paint to dry paper. Move the brush from side to side, beginning at the top of the paper and working your way down to the bottom. Add water to your paint mixture, making sure that it is well mixed into the brush. Quickly continue painting to maintain a smooth transition, getting gradually lighter as you go. Figure A shows the proper direction and movement of the brush.

Poor Value Shifts

Figure B demonstrates a poorly executed graded wash, as the obvious and sudden jump in value creates streaks in the wash.

Good Value Shifts

Figure C is an example of a successful graded wash. The value is darkest at the top of the paper and gradually gets lighter as it continues downward.

WET-IN-WET

With watercolor, you can either apply your paint while your paper is wet or when it is dry. Painting into wet areas gives you a soft, diffused look with no hard edges. This is because the paint will flow into the existing wet areas and mix with the water on the paper. This approach is known as painting *wet-in-wet*. This is a good technique for painting soft, fuzzy or nebulous subjects such as fog, clouds, water spray or objects seen through the mist. It is also excellent for showing depth (objects become less sharp as they move away from the viewer) and for painting abstract areas within your composition.

When working wet-in-wet, start by totally wetting your paper with a large brush or sponge or by immersing your paper in water. While the paper is still wet, liberally daub or flow paint into the wetness, allowing it to spread or run in the direction that the paper is tilted. Once finished, you can add other colors, allowing them to mix on your paper. Change colors to create an interesting and vivid design.

As I mentioned before, there are no hard edges when painting wet-in-wet. Depending on how dry you let the paper become, though, additional washes may be applied after the first wash dries to create the effect of harder edges. Manipulating your washes in this way, you can build outward from softer areas to harder, more defined objects. Another option for creating hard edges is to wet your paper down only in certain spots or areas, painting wet-in-wet in these confined spaces rather than the entire sheet of paper.

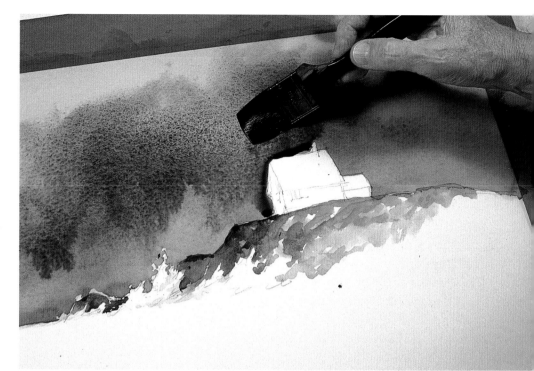

Painting Wet-in-Wet
Daubing a fully loaded brush into the wetness of an already painted sky adds more dramatic clouds and deepens the darker values. Getting the paint to flow in the direction and at the speed you want depends on having the paper at the right degree of wetness. This will come more easily with experience.

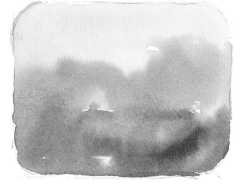

An Abstract View
Painting wet-in-wet works well for abstract areas such as distant backgrounds where no detail is required.

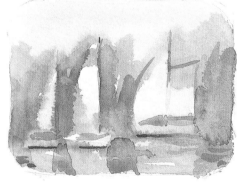

A Softer Touch
This example shows how objective or realistic subjects appear when painting wet-in-wet. Notice the soft, gentle edges of the sky, background foliage, water and sailboats, a characteristic of this technique.

WET-ON-DRY

Applying paint from the brush directly onto dry paper is known as painting *wet-on-dry*. With this technique, you can develop sharp focus, definition and detail to unify the various parts of your painting and complete your visual statement.

The object of any painting technique is to re-create a picture for the viewer. That picture is made up of numerous different elements, including solid objects like trees and mountains, and ethereal areas such as skies and water. These individual parts of the painting are created through the indication of form. You can create form with the wet-on-dry technique by depicting shapes or silhouettes of objects, then adding definition to give the illusion of three dimensions.

Whereas wet-in-wet works well to create soft edges, wet-on-dry is the primary technique for creating hard edges. Too many hard edges, though, can often destroy the illusion of depth within a composition. If you find this happening in your painting, don't panic. You can soften selected edges while the paint is still wet by going over them with your brush and some clean water. In fact, to successfully re-create many scenes will require you to use wet-on-dry in conjunction with wet-in-wet. For example, if painting a landscape with mountains in the background and houses in the foreground, you would use wet-in-wet to give the mountains a softer, more distant appearance and wet-on-dry to sharply define the houses. I encourage you to experiment using both techniques together in your paintings, finding a balance you're comfortable with.

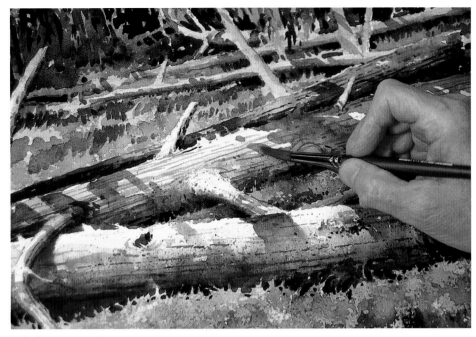

Painting Wet-on-Dry
When painting wet-on-dry the paint will stay pretty much where you put it, giving you more direct control over the outcome of your brushstrokes. Use this technique when you want objects to have hard edges and detailed definition.

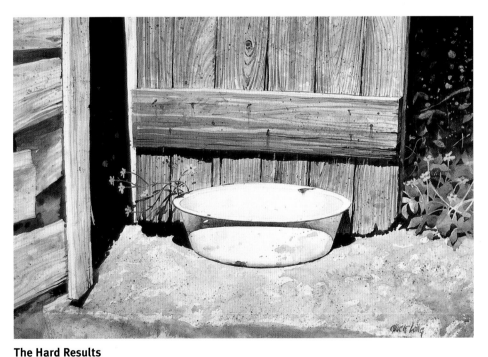

The Hard Results
This scene has very few soft areas. To accurately portray the hard edges of the clapboard siding, as well as the wood lines and jagged bottom of the cabin's door, I utilized the wet-on-dry technique.

WASH TUB
15" X 20" (38CM X 51CM)

EXERCISE | COMBINING WET-IN-WET AND WET-ON-DRY TECHNIQUES

As I mentioned before, accurately depicting many scenes mandates using both wet-in-wet and wet-on-dry techniques. The painting in this exercise is a perfect example of such an instance. In particular, I wanted the background to be soft and misty, with objects coming into sharper focus as they approached the viewer.

I used a black-and-white value sketch to work out the composition and values before I began painting. Wet-in-wet was utilized to achieve the desired softness and a sense of depth, while wet-on-dry helped create the necessary detail.

MATERIALS LIST

Surface	300-lb. (640gsm) cold-pressed paper
Brushes	Nos. 8 and 12 rounds
Watercolors	Brown Madder
	Burnt Sienna
	Cadmium Yellow Medium
	Cerulean Blue
	Phthalo Violet
	Raw Sienna
	Sap Green
	Ultramarine Blue
Other	HB pencil

Thumbnail Value Sketch

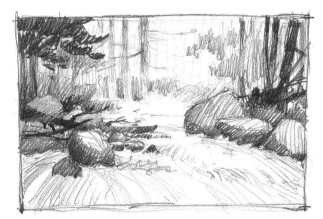

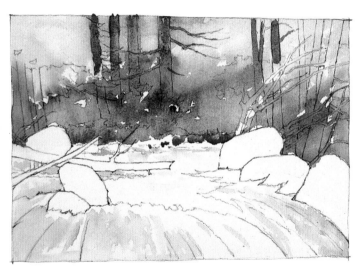

1 Draw Guidelines and Lay Initial Washes

Once you've drawn the necessary guidelines on your paper, wet down the background using clean water and your no. 12 round. Then lay Cerulean Blue followed by Sap Green into the wetness. Paint Ultramarine Blue and Burnt Sienna into selected areas, all wet-in-wet. Combine the same blue and brown colors to indicate the darker vertical trees and some of the dead limbs on the right. Use Sap Green and Ultramarine Blue for the first washes in the rushing water.

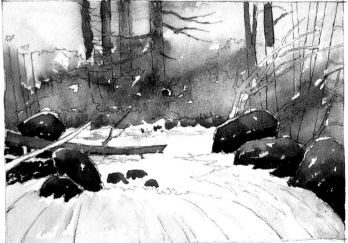

2 Paint the Middle Ground

Paint the rocks using your no. 12 round and a gray mixture of Burnt Sienna and Ultramarine Blue. While still wet, flow pure Burnt Sienna followed by Ultramarine Blue into the wet rocks, controlling the flow in order to create form. Do this with the direction of the light coming from the right in mind. Paint the dead log with Raw Sienna and the grassy area at left with a mixture of Sap Green and Ultramarine Blue. Allow some green to creep into the log.

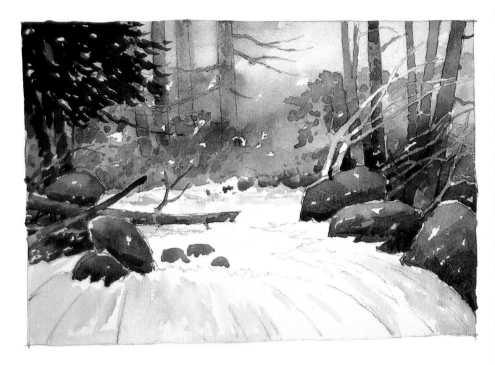

3 Add Darker Values

Use your no. 12 round and a mixture of Sap Green and Raw Sienna to paint the background foliage, allowing it to gradually fade out. Lay down Ultramarine Blue in a similar fashion. Paint the small log on the far left using your no. 8 round and a mixture of Ultramarine Blue and Burnt Sienna. Use the same mixture with Phthalo Violet to paint the trees on the right and the spaces behind the smaller limbs and trees. Use darks made with the same colors behind the rocks and within the rocks to create more form. Let your paper dry.

Now working wet-on-dry, develop the logs and debris on the left using your no. 8 round and a mixture of Burnt Sienna and Ultramarine Blue. Paint the tree on the left using the same mixture with Phthalo Violet for the trunk and Sap Green and Ultramarine Blue for the foliage. Allow your paper to dry again.

4 Paint the Rushing Water

Create action in the water using your no. 8 round and various combinations of Ultramarine Blue, Sap Green and Cerulean Blue. Develop this first with the wet-on-dry technique, then flow additional color into the wetness using the wet-in-wet technique. Take care to preserve the whites in the rapid water. Add some warmth to the left side, recalling the yellows and browns at the right, using Cadmium Yellow Medium and Brown Madder. Add gray spatter (see page 65) to the rocks for texture.

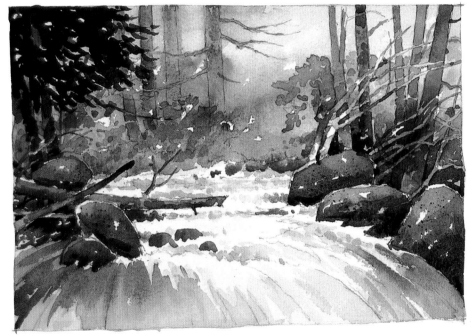

MISTY STREAM | 6" X 9" (15CM X 23CM)

DRYBRUSH

Drybrush is a misnomer. You can't paint anything with a dry brush! What this term really means is that comparable to other techniques, the brush holds very little paint or water. In drybrush, most of the paint is removed from the brush by raking the bristles across an absorbent surface such as a paper towel, rag or tissue. The barely wet brush is then scraped across paper, depositing paint only on the high points of the paper's surface and creating the illusion of texture. By comparison, a fully loaded brush would flow paint over both the high and low points of the paper's surface, creating an overall smooth wash with no texture.

Andrew Wyeth was the first painter that I know of to use the term *drybrush*. He made masterful use of this technique to create richly colored textures balanced by the sparkle of unpainted paper showing through. Drybrush is excellent for depicting the roughness of rocks, weathered wood, tree bark, dirt, gravelly roads and more. I encourage you to experiment with this technique and have fun!

The Possibilities of Drybrush
These examples of various brushstrokes illustrate the dry-brush technique. By simply alternating pressure, you can indicate lighter or darker texture.

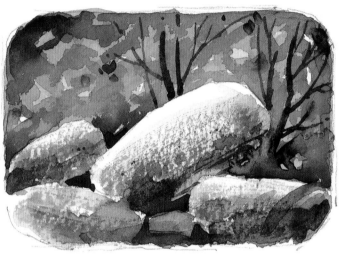

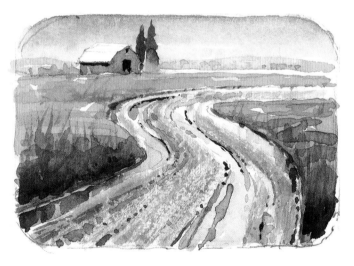

Creating the Illusion of Texture
Drybrush can be used to create a variety of textures for different subjects. Using the dry-brush technique, I was able to indicate the smoothness of large rocks, the roughness of a dirt road, and (through built-up applications) the coarseness of weathered wood and peeling paint.

SPONGE TECHNIQUES

Sponge painting is like printing. Load the sponge with paint, press it onto the paper and presto—you've got an image showing color, shape, form and texture! Well, it's not quite that simple, but like everything else, with practice you can get exciting results.

Sponges come in all manner of sizes, types and surface textures. Each type has its own individual characteristics and is unique in shape, fineness and coarseness, making the texture-creating possibilities endless. Select a number of sponges, both natural and artificial, to experiment with, and find the type which works best for you.

The Natural Sponge
When using a natural sponge you will notice that the negative spaces, or the white spaces between the painted spaces, are generally small and porous. As a result, I find natural sponges work well in instances where minimal negative space is desired. In this example, Alizarin Crimson, Raw Sienna, Phthalo Blue and Phthalo Green were applied separately and then allowed to intermix on the paper.

The Artificial Sponge
In comparison to the natural sponge, the negative spaces created with an artificial sponge are more obvious. I favor this type of sponge for most tasks, as I feel it has the proper proportion of positive and negative space. In this example, Ultramarine Blue, Burnt Sienna, Brown Madder and Sap Green were applied separately and then allowed to intermix on the paper.

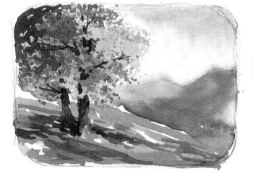

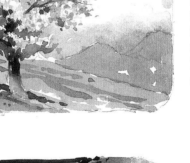

Side-by-Side Comparison
The tree foliage on the left was created using a natural sponge, while the foliage on the right was created with an artificial sponge. Examine the difference in negative space between the two examples. While sparse in the tree foliage on the left, negative spaces are quite obvious in the foliage on the right, resulting in a better overall balance of positive and negative space.

PAINTING POINTER

With the exception of wetting down your paper, extremely fine textured sponges don't work well for most tasks. I find that these sponges don't make much of an impression when it comes to imparting texture, as the results are too timid and fine to make a strong visual statement. To ensure better results, I suggest using sponges that range from slightly coarse to extremely coarse in texture, depending upon the desired effect.

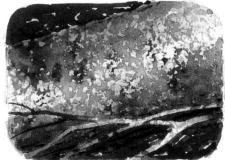

Indicate Tree Bark
Adding texture to the trees and logs in your paintings can make all the difference. Artificial sponges work well for creating rough and obvious bark. Use a natural sponge to suggest barks with smoother and subtler textures.

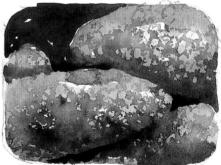

Rough up Your Rocks
Use a sponge to give the rocks in your paintings a rough and weathered appearance. First paint the rock shapes, allowing them to fully dry, then apply various color applications with your sponge to add form and texture.

LINE TECHNIQUES

*L*ine, for the most part, is a drawing technique and should be kept to a minimum in painting. Three-dimensional objects are usually defined by shapes, sides, planes, flat surfaces, rounded surfaces, multifaceted areas and so on. When painting these objects, then, we need to show the defining structures as they appear to us by using washes—flat or graded—to create the illusion of these objects. The eye does not see outlined objects, but rather sees shapes and planes separated from one another by changes in color or value. There is no dividing line.

Some painters from the impressionistic, late romantic, and modern eras employed the stylized technique of outlining objects with dark lines to give emphasis. This is stylization and not realism. However, there are times when lines do occur naturally within a scene and should be included in your statement. Examples include telephone lines, masts or rigging on boats and ships, wooden boards and fencing. Ultimately, though, whether or not to use line in a composition is a conscious choice that the artist must make.

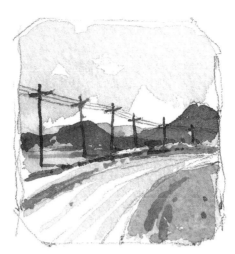
Telephone Lines and Poles

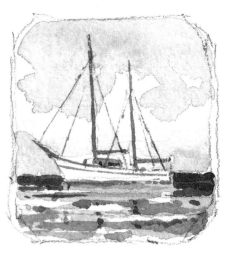
Boat Rigging

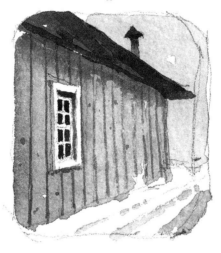
Wooden Boards

Fencing

Examples of Lines Within a Composition

A pointed round brush holds lots of paint and works well for creating thick or fine lines.

These lines were created with a flat brush, using the blade edge first then the broad edge.

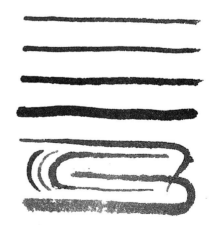

By using a rigger brush you can compose lines of varying thickness.

Brush Performance
Lines are achieved in painting with several types of brushes.

SPATTER AND SPLATTER

Spatter and *splatter* may seem to be the same thing, but there is a difference. To spatter, take a stiff brush such as a natural hog bristle and load it with paint. Then flip the bristle end with your finger, letting little spats of paint fly over certain areas of your painting. The bristles are pulled away from the painting and then let go, flinging the spatter forward like a spray. This technique works well for creating texture in things like rocks or dirt roads. You have to be careful, though, and control the flight of the spatter. For example, it's not good to spatter your sky unless you want to show lots of bugs in the air. But who knows; perhaps you will want to portray a locust plague!

The splatter technique is similar, but with a definite difference. Splattering is done with a softer brush, like a mid- to large-size round, that is loaded with paint and then tapped against your opposite index finger. This action sends fragmented splats of paint flying into areas of the composition. Splatter is more directional and generally has a stronger effect than spatter. A great deal of paint goes into areas of your painting at an angle that is determined by the direction of the brush's arc as it collides with your finger. It can add interesting, spontaneous and effective touches to organic subjects such as weeds, tree limbs and foliage. As with spatter, splatter should be used with care and not overdone. A little can go a long way!

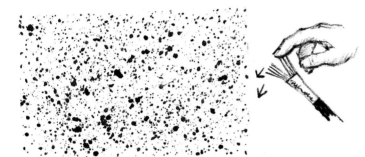

Spatter

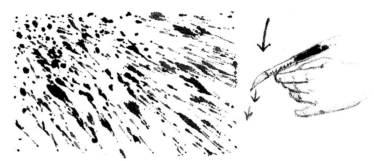

Splatter

When to Use Spatter
Spatter is a good technique for indicating the texture of rocks, dirt roads and more.

When to Use Splatter
Splatter works great for organic subject matter such as weeds, cockleburs, flotsam and other things that grow.

EXERCISE | INCORPORATING BRUSH AND SPONGE TECHNIQUES

This painting is a combination of contrasting textures—hard, rough rocks and coarse weeds versus soft grass and wildflowers—all achieved with the combined use of brushes and sponges. Each tool produces unique effects that are characteristic of that particular instrument, creating rich variety in texture. The fan brush's stiffness is perfect for various strokes and spatter, while the sponge creates additional texture with negative spaces.

Thumbnail Value Sketch

MATERIALS LIST

Surface	300-lb. (640gsm) cold-pressed paper
Brushes	Nos. 8 and 12 round No. 3 hog-bristle fan blender Old no. 3 round (for masking fluid)
Watercolors	Burnt Sienna Cadmium Yellow Medium Phthalo Violet Raw Sienna Sap Green Ultramarine Blue
Other	Artificial sponge HB pencil Masking fluid Masking tape

1 Draw Guidelines and Rough in Grass

Mask the borders of your paper with masking tape and draw in major guidelines using your HB pencil. Once finished, use an old no. 3 round to apply masking fluid to the small wildflowers in the lower left. Next, rough in the yellow-green grass using your no. 12 round and a mixture of Sap Green, Cadmium Yellow Medium and Raw Sienna. Paint this mixture up to the silhouettes of the rocks. With the same mixture and your fan brush, indicate the high grass behind the rocks, painting with mostly upward vertical strokes.

2 Add Texture to Grass and Form the Rocks

Still using your fan brush and various combinations of the same mixture, create weed-like textures in the grass, twisting the bristle end of your brush from left to right as it touches the paper. While still wet, repeat using Burnt Sienna, laying graded applications that move from dark to light to suggest the lit and shaded areas of the grass. Using your no. 12 round and combinations of Burnt Sienna and Ultramarine Blue, form the rocks using the wet-on-dry technique, making sure to indicate light and shadow. Use a clean, wet brush to soften and lose edges, then allow your paper to dry.

3 Add Sponge Texture to Rocks

Add texture to the rocks using your sponge and combinations of Ultramarine Blue and Burnt Sienna, being careful to maintain the light and shadow painted on the rocks in step 2. Add more grass and weed texture using the tip of your fan brush and a mixture of Sap Green and Ultramarine Blue. With the same brush and mixture create additional texture, adding spatter to the grassy areas. If you feel unable to control your spatter at this point, cover the rocks with scrap paper to protect them from paint spats intended for the grass. Once finished, lay in the background in the upper right-hand corner with the same brush and mixture, painting around individual blades of grass to create added dimension.

4 Add Final Details

Still using the mixture of Sap Green and Ultramarine Blue, paint small spaces between chunks of grass with your no. 8 round. Enhance lighter grass shapes and textures by emphasizing the surrounding darker areas. These strokes indicate foliage and stems and add more depth to the grass. Remove the masking tape from the border and the masking fluid from the small wildflowers. Add more texture and cracks to the rocks using your no. 8 round and a mixture of Ultramarine Blue and Burnt Sienna. Then, place cast shadows made with Phthalo Violet and Ultramarine Blue over some of the rocks. Finally, paint the centers of the wildflowers using your no. 8 round and Cadmium Yellow Medium.

ROCKS IN A FIELD | 6" X 9" (15CM X 23CM)

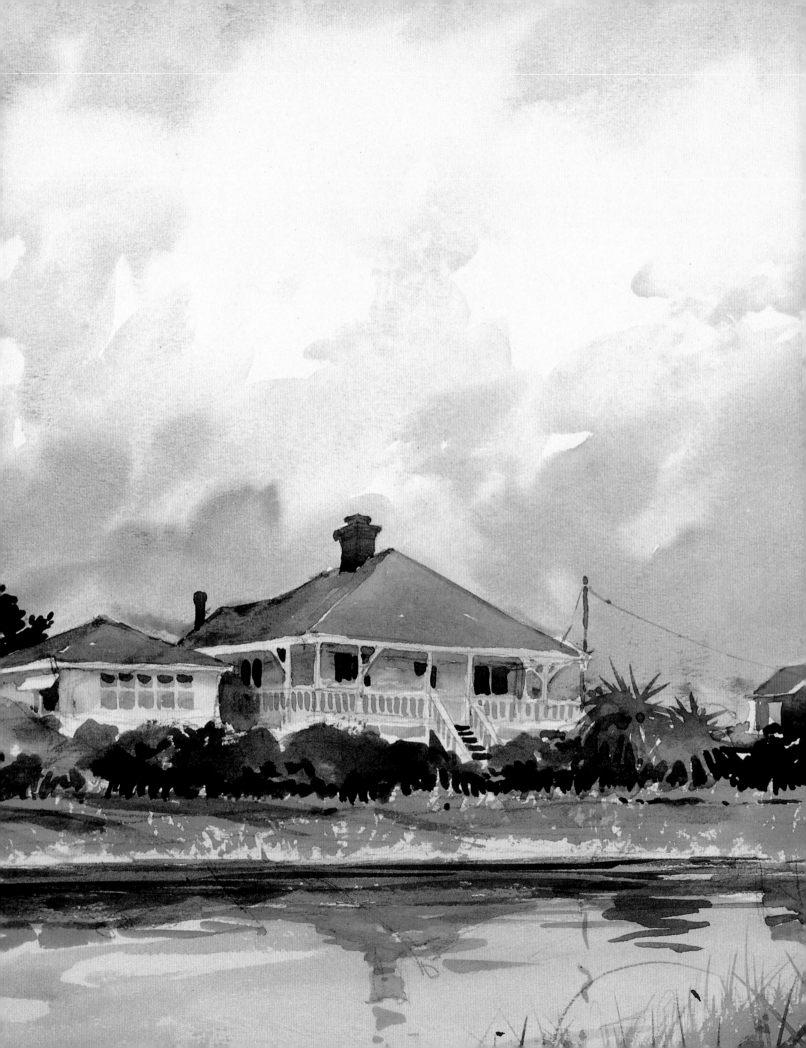

5 LESSONS IN DRAWING AND PERSPECTIVE

A TEXAS LIGHTHOUSE
15" X 20" (38CM X 51CM)

KEY-LINE DRAWINGS

The first step towards designing a composition is creating a *key-line drawing*, or a quick line drawing that indicates the position, shape, size and proportion of the objects within the composition. A key-line drawing serves only as a guide for your painting, so it isn't necessary to draw every single line that will appear in your finished composition. Don't worry about filling in details. Instead, you need only draw the most essential lines, leaving you with a base for your painting.

It is helpful to begin your key-line drawings by placing tick marks on your paper that indicate where the top, bottom, right and left sides of the subject will be. Then place additional tick marks in other key areas of the composition. Once you feel confident with the position of the subject, begin drawing outlines of the major objects in the composition. Remember, don't worry about details at this stage. The important thing here is that you're satisfied with the placement, shape, size and proportion of the objects within your drawing.

DRAWING FREEHAND

Using a straight edge is helpful in many instances, but there are times when it can hinder your drawings. Though it may be easier in the beginning to rely on a straight edge, it can sometimes make your drawings (and paintings) look rigid and mechanical in appearance. If your lines look too carefully calculated, your design will be boring and lack feeling. To avoid such an outcome, you should discipline yourself to use freehand lines whenever possible. Don't worry if your lines aren't perfectly straight; the wavering, bowing nature of freehand lines will create variation, and ultimately interest, in your design.

Placing Tick Marks
Tick marks help to position objects on your paper. Connect the marks to finish the key-line drawing.

Creating a Key-Line Drawing
The key-line drawing is your guide for the painting and should look fairly similar to the drawing you place on your watercolor paper before painting.

VALUE SKETCHES

Once you have completed a key-line drawing, the next step is to anticipate the values of your composition. This is achieved through creating a *value sketch*, or a plan that helps the artist place values within a composition. A value sketch is an irreplaceable tool for translating the values within your scene into the right degree of light, middle and dark values in your painting. Reducing the values you observe to three shades of gray, plus white, helps simplify this translation from scene to finished painting.

When creating your value sketch, don't worry about minute details. Rather than make a full-scale drawing, you can simply complete a *thumbnail sketch*, or a small, quick synopsis of the simplified values within the scene. To gauge the values for your thumbnail sketch, simply squint at your object and draw what you see. This process drops out the more subtle values, leaving you with the most basic values—lights, middles and darks.

Completing a Thumbnail Value Sketch
Use a small piece of white drawing paper (roughly 3" x 5" [8cm x 13cm] in size) and a soft graphite pencil to complete your thumbnail sketch. Rough in the basic values of the scene, pressing hard with your HB pencil to create dark values and reducing the pressure applied to create light values.

PENCIL BEFORE PAINT

Drawing on watercolor paper you intend to use for an actual painting should be kept to a minimum. However, if you feel you need guidelines to follow, use a soft HB pencil. Draw just dark enough that your lines will be visible through light and middle valued washes, and never add shading, as too much graphite will negatively affect your painting. Also be careful when erasing unwanted pencil lines. I recommend using soft erasers, since they are less likely to disturb the surface fibers of the paper. Remember that abrasions, scratches or other damage on the paper's surface will show up in your painting, so use caution!

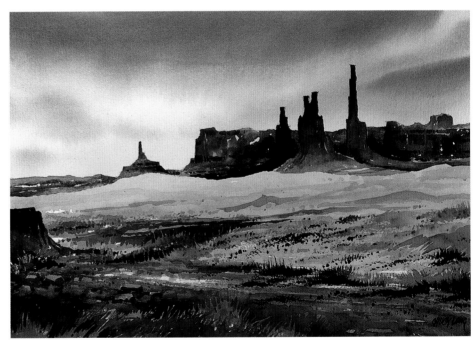

Translating Your Sketch Into a Painting
The finished watercolor should evolve from your value planning, reflecting the light, middle and dark values from your thumbnail sketch.

MONUMENT VALLEY
15" X 20" (38CM X 51CM)

UNDERSTANDING PERSPECTIVE

Perspective is the art of depicting objects so that the illusion of depth or three dimensions exists on a two-dimensional surface. Understanding perspective and how to utilize it properly in your drawings will help keep your compositions from looking flat and lifeless, making it an important part of the painting process.

To achieve an accurate sense of depth in your compositions, you must first understand how the eye records spatial relationships when examining three-dimensional scenes. When viewing any scene, the artist looks through the *picture plane*, an imaginary, transparent, two-dimensional surface that lies between the artist and the scene. This picture plane is similar to a plate of glass, as all of the elements that lie beyond the plane are visible to the viewer. The viewer examines the spatial relationships that exist in the scene, including the distance between objects and the progression of depth, and then captures the scene on the picture plane just as film in a camera would.

Once the three-dimensional scene has been recorded on the two-dimensional picture plane, the artist is faced with the challenge of converting the scene back into the illusion of three dimensions on paper or canvas. This is achieved through indicating the supposed distance of objects beyond the picture plane. That is, in looking at the relationship between objects in the scene and their relationship to the space around them, you will discern that some objects appear closer than others. To achieve this illusion of depth on your paper, vary the size of the objects. The objects closest to you should be the largest and should decrease in size the further away from you they are. Overlapping objects in your drawings and paintings also gives a sense of depth, as it helps the viewer establish the distance between the objects in your painting.

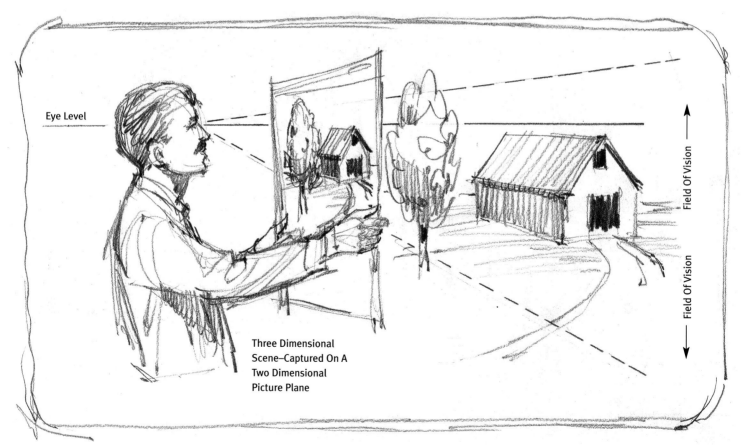

Eye Level

Three Dimensional
Scene–Captured On A
Two Dimensional
Picture Plane

Field Of Vision

Field Of Vision

The Picture Plane
Any three-dimensional scene viewed by the artist is filtered through an imaginary, flat, two-dimensional plane known as the picture plane, which shows the artist how distant objects relate to each other on two-dimensional surfaces.

AERIAL PERSPECTIVE

Oftentimes when you are viewing a scene in nature, the perception of depth is intensified by the presence of *atmospheric haze*, or covering mists and vapors that make objects appear farther away. The form of perspective that deals with portraying these hazes is known as *aerial perspective*.

Objects depicted in aerial perspective vary in color, value and focus depending on how close or far away they are in relation to the viewer. To achieve aerial perspective in your drawings and paintings, make the objects that you want to appear closest to the viewer strong in color and value, keeping them in sharp, clear focus. Conversely, to create the illusion of distance use softer focus, making the objects bluer, lighter and duller the further they get from the viewer. This basic premise is most obvious when viewing mountain ranges, as those closest to you look crisp in detail and those farthest away appear soft and blended.

Aerial Perspective at Work
Notice the grasses, field and house in the foreground and middle ground of this painting are in sharp focus. As the scene recedes into the distance, though, the trees and mountains become lighter and hazier. The farthest mountain is even cooler in hue, creating the illusion of distance.

The Role of Weather
The presence of fog, rain, mist, smog and other weather conditions contributes to aerial perspective. For example, the early morning fog and mist in this scene subdue the distant shore, pushing it miles away into the background. Also notice the intermediate rocks are darker, warmer and more defined than those behind it, further illustrating the principles of aerial perspective.

LINEAR PERSPECTIVE

When most people think about perspective, they're thinking about *linear perspective*, a system of drawing that uses receding lines to create the illusion of spatial depth on a two-dimensional surface. In linear perspective, all horizontal parallel lines recede or diminish as they go away from the viewer and converge at a point on the viewer's *eye level*. The eye level, incidentally, always coincides with the horizon line, regardless of where you're looking. This point on the horizon to which all lines converge is known simply as the *vanishing point*.

Linear perspective can be divided into three categories: one-point, two-point and three-point perspective. The following pages will discuss each of these, illustrating the differences between the three.

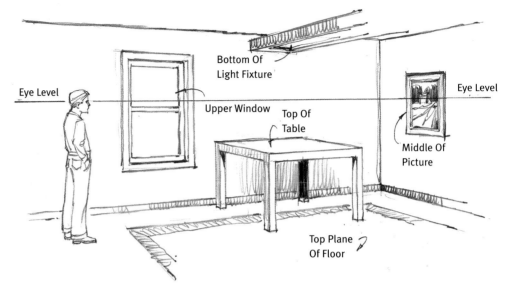

A Relative View
Everything the viewer sees is relative to his eye level. For example, objects above eye level are seen from the bottom up, while objects below eye level are seen from the top down. Objects directly at eye level are viewed at the middle, showing neither top nor bottom.

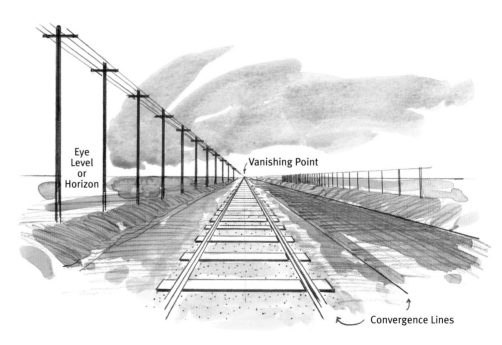

Seeing in Linear Perspective
When viewing a scene, horizontal parallel lines appear to converge in the distance. Linear perspective helps illustrate this in drawings or paintings, as lines slant inward to look as though they are extending back into space.

In this example, the railroad track, road and poles are the parallel horizontal lines. Notice how these lines narrow as they move away from the viewer, eventually converging at a vanishing point on the viewer's eye level.

ONE-POINT PERSPECTIVE

One-point perspective is the simplest method of conveying the illusion of three dimensions. In one-point perspective the viewer is looking directly at the object, seeing it head-on rather than at an angle. Thus, the parallel lines (and the objects that lie on these lines) recede into the depth and meet at a single vanishing point, which lies straight ahead on the viewer's eye level. This means that the lines become increasingly narrow and the objects along the lines gradually diminish in size as they move toward the single vanishing point.

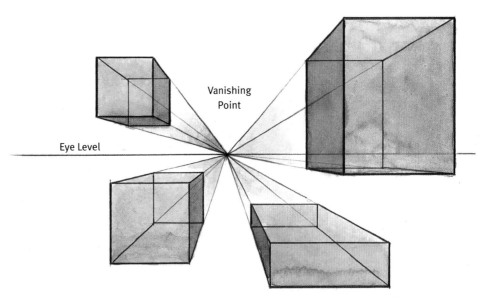

Vanishing Point

Eye Level

The Effects of Eye Level

Here four boxes are shown in varying relationships to the eye level and to each other. Notice the planes that are visible because of the boxes' positions. If the cubes were directly on eye level with the viewer, only the front surfaces would be visible, meaning the viewer would see only squares or rectangles. However, as the cubes move up or down from the viewer's eye level, the top or bottom planes become visible.

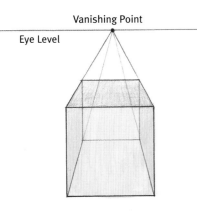

Vanishing Point

Eye Level

One-Point Perspective

This cube, resting below eye level, has only one set of parallel lines that recede and vanish at eye level, making it an example of one-point perspective.

An Example of One-Point Perspective

This cityscape shows the dramatic effects of one-point perspective. The viewer's eye is drawn directly to the building at the end of the street, as all of the lines in the picture converge at the single vanishing point hidden inside of this building. Also notice how the objects in this illustration get smaller as they go away from the viewer.

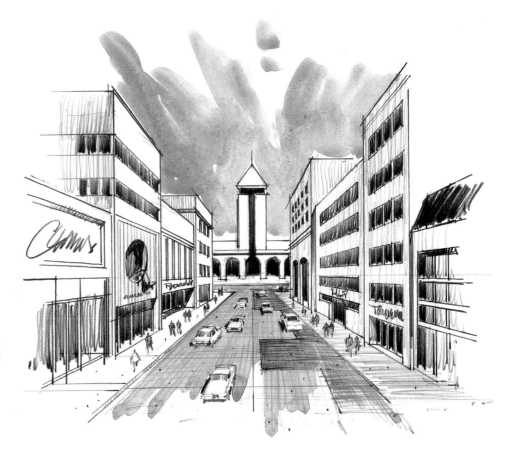

TWO-POINT PERSPECTIVE

Two-point perspective is a bit more complex than one-point perspective, as the viewer observes the object from an angle instead of head-on. As a result, at least two sides of the object are visible at eye level. This means that there will also be two vanishing points on the horizon, with all lines appearing to meet at either of these two points. The positioning of the two vanishing points will depend on the viewer's relationship to the object.

The spot where the viewer is standing is the viewer's vantage point. If the viewer sees more of one side than the other, the vanishing point for the foreshortened side (the more obscured side) will be close to the object, while the vanishing point of the more visible side will be further away.

When creating a painting in two-point perspective, make sure you accurately locate the horizon line within your composition and place your objects accordingly. For example, if the eye level splits the object, the viewer should see neither the top nor bottom of the object. If the object lies above eye level, its top should be hidden, with only its bottom visible to the viewer. Conversely, an object below eye level should have only its top showing, with its bottom obscured. Also be careful not to place the vanishing points too close to the object, as this will give you a distorted view.

Two-Point Perspective

Examine these three boxes shown in two-point perspective, each placed in different proximity to the viewer's eye level. The blue box is suspended above eye level, obscuring the top plane of the box while leaving the bottom plane visible. The red box, on the other hand, is placed below eye level, obscuring the bottom plane of the box and leaving the top plane visible. Notice, however, that neither the top nor bottom plane of the yellow box is visible. This is because the yellow box rests directly at eye level.

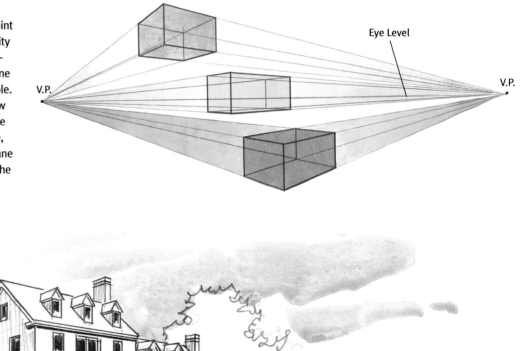

An Example of Two-Point Perspective

In this example, the viewer is looking at the house from an angle. Both the front and left sides of the house are visible, indicating that there are two vanishing points. Since the front of the house is more visible from the viewer's vantage point, the vanishing point on the right is farther away from the house, while the vanishing point on the left (the more foreshortened side) is closer to the house.

THREE-POINT PERSPECTIVE

Like two-point perspective, *three-point perspective* has two vanishing points somewhere on the horizon. However, in three-point perspective there is an additional vanishing point that runs vertically, either above or below eye level. This third point, which I call the *vertical vanishing point*, is the place where all vertical lines converge. In order for a vertical vanishing point to exist, the viewer must be observing an object from a top or a bottom view. In other words, three-point perspective is only apparent from either great heights or great depths. For example, if you are looking upward at the top of a skyscraper, a vertical vanishing point will lie above the horizon line. Similarly, if you are looking down into a canyon, a vertical vanishing point will lie below the horizon line. When vertical lines are close to or on your eye level, they will appear perfectly vertical without taper or distortion.

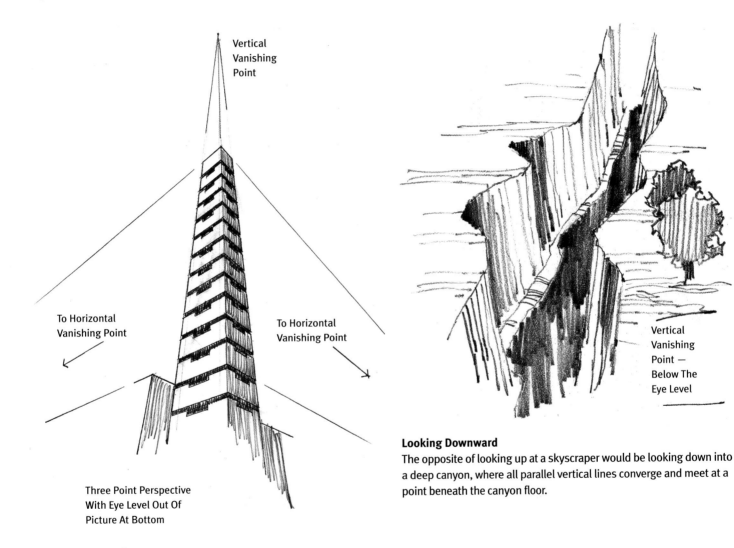

Vertical Vanishing Point

To Horizontal Vanishing Point

To Horizontal Vanishing Point

Three Point Perspective With Eye Level Out Of Picture At Bottom

Vertical Vanishing Point — Below The Eye Level

Looking Upward
The three corners of this skyscraper are represented by parallel vertical lines that converge and meet at a vanishing point above the top of the building.

Looking Downward
The opposite of looking up at a skyscraper would be looking down into a deep canyon, where all parallel vertical lines converge and meet at a point beneath the canyon floor.

EXERCISE | WORKING WITH PERSPECTIVE

Any architectural subject requires more attention to perspective than natural landscapes or other types of compositions, but the challenge is well worth it. Though the majority of this scene is viewed in one-point perspective, with horizontal parallel lines converging and meeting at a single vanishing point, the two houses at the far end of the street are viewed in two-point perspective. Also notice that the houses get slightly lighter in value as they move away from the viewer, illustrating aerial perspective.

Thumbnail Value Sketch

MATERIALS LIST

Surface	300-lb. (640gsm) cold-pressed paper
Brushes	Nos. 3, 8 and 12 rounds
	No. 3 hog-bristle fan blender
Watercolors	Alizarin Crimson
	Burnt Sienna
	Cadmium Red Light
	Cadmium Yellow Medium
	Cerulean Blue
	Phthalo Violet
	Raw Sienna
	Sap Green
	Ultramarine Blue
Other	HB pencil

1 Draw Key Lines and Paint in Sky
After drawing key lines with your HB pencil, lay in the sky on dry paper using your no. 12 round and a wet mixture of Cerulean Blue, Raw Sienna and Alizarin Crimson. While your paper is still wet, place a few darker values of the same colors to create a cloudy effect.

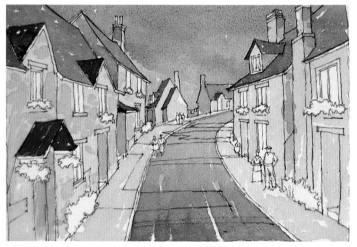

2 Paint the Stone Walls and Street
Using your no. 12 round and a mixture of Burnt Sienna, Raw Sienna and Ultramarine Blue, paint all walls, keeping the value of the houses light and sunny. Daub on several slightly darker strokes of the same mixture to indicate the texture of stone. Lay in the street using the same color mixture with more Ultramarine Blue to darken and gray the road as it gets closer to the viewer. Lighten this same mixture with water and paint over the sidewalks. Paint the roofs using various mixes of Burnt Sienna and Ultramarine Blue, making the roofs closest to the viewer slightly darker and more intense in value.

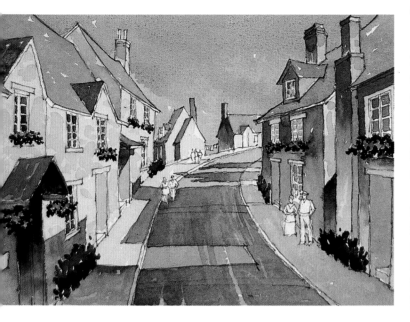

3 Add Cast Shadows

Using your no. 8 round, place a mixture of Burnt Sienna, Ultramarine Blue and Phthalo Violet over the walls of the houses on the right to create shadows. Save sunny areas and lighten values at the bottom to indicate reflected light. Cool this same mixture with Ultramarine Blue, painting shadows over the sidewalk and road and into the houses on the left. Place cool shadows under the roof canopies on the left using a mixture of Ultramarine Blue and Burnt Sienna. Allow your paper to dry.

Add window details with your pencil. Paint the panes with your no. 8 round and mixtures of Cerulean Blue, Ultramarine Blue and Sap Green. Create flowers in the planters on the left using Cadmium Red Light and Cadmium Yellow Medium for the blossoms, and Sap Green and Raw Sienna for the foliage. Repeat this process for the flowers on the right, using Alizarin Crimson and Raw Sienna for the blossoms, and Sap Green and Ultramarine Blue for the foliage.

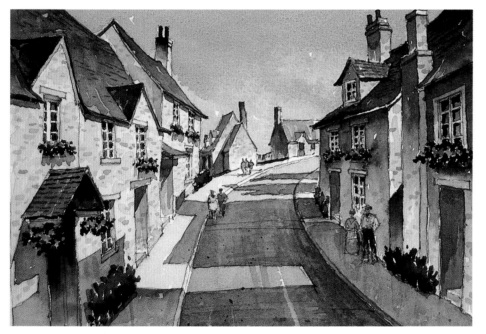

COTSWOLD VILLAGE | 6" X 9" (15CM X 23CM)

4 Add Texture and Final Details

Darken the roofs on the right side using your no. 8 round and a mixture of Ultramarine Blue and Burnt Sienna. Add shadows on the windows using Sap Green and Ultramarine Blue. Paint additional shadows under the roofs and planters on both sides, as well as the entryways on the right, using a mixture of Phthalo Violet, Ultramarine Blue and Burnt Sienna. With the same mixture, paint shadows and detail into the two houses at the far end of the street. Lay in darker values on the roofs to the left using a combination of Burnt Sienna and Ultramarine Blue. While still wet, drop in more Ultramarine Blue to darken and intensify. Add texture to the roofs and indicate selected stones on the walls using a mixture of Burnt Sienna, Raw Sienna and Ultramarine Blue. Darken the sidewalk and street with the same mixture. Let your paper dry.

Now using your no. 3 round, paint the people and clothesline using various colors from the materials list. Spatter finishing touches on the street and sidewalk using your no. 3 fan blender.

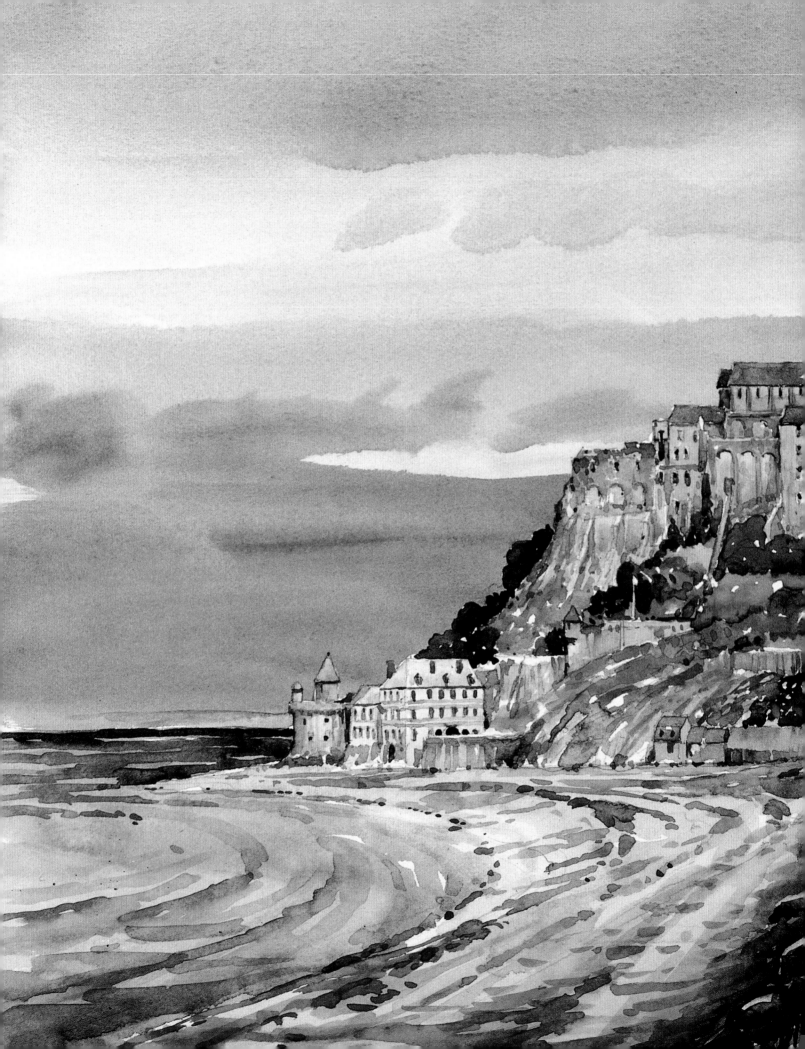

6 STEP-BY-STEP DEMONSTRATIONS

MONT ST. MICHEL
15" X 20" (38CM X 51CM)

DEMONSTRATION | LAKE LOUISE

Located in the midst of the Canadian Rockies, the placid beauty of Lake Louise's blue-green water and surrounding mountain peaks makes for a beautiful watercolor painting. And with just enough detail to exercise your developing artistic skills, this demonstration serves as the perfect starting point for the beginning painter.

To create the illusion of dramatic movement in the sky, I used the wet-in-wet technique. I laid several consecutive flat and graded washes to create form and dimension in the mountains and created texture in the forested areas with my round brushes.

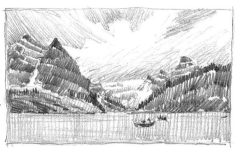

Thumbnail Value Sketch

MATERIALS LIST

Surface	Crescent 114 watercolor board
Brushes	No. 3 hog-bristle fan blender
	Nos. 8, 12 and 26 rounds
	1-inch (25mm) flat
Watercolors	Brown Madder
	Burnt Sienna
	Cadmium Red Light
	Cadmium Yellow Medium
	Cerulean Blue
	Phthalo Violet
	Raw Sienna
	Sap Green
	Ultramarine Blue
Other	HB pencil
	Natural sponge
	Paper towels

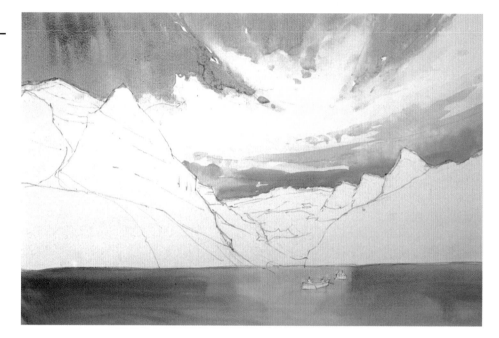

1 Lay in the Sky and Water

After completing your initial drawing with an HB pencil, wet down portions of the sky using clean water and your sponge, patting only the areas around clouds and leaving the remainder of the sky dry. Using your 1-inch (25mm) flat and a mixture of Cerulean Blue and Ultramarine Blue, paint into the wet areas, allowing the colors to run downward. Use a paper towel or a wet brush to soften and blend some edges. Still using your 1-inch (25mm) flat, lay a lighter wash of the same sky mixture into the underside of the clouds, preserving the white of the paper for the tops of the clouds. While still wet, paint a grayed violet mixture of Phthalo Violet, Ultramarine Blue and Cadmium Yellow Medium just above the distant mountains, allowing the wash to fade as it moves upward. Next, use your 1-inch (25mm) flat to wet the lake area, carefully painting around the two canoes. While still wet, flow in a mixture of Sap Green, Ultramarine Blue and Cerulean Blue. Lay a darker mixture of the same colors on the right and left sides of the lake. Let your paper dry.

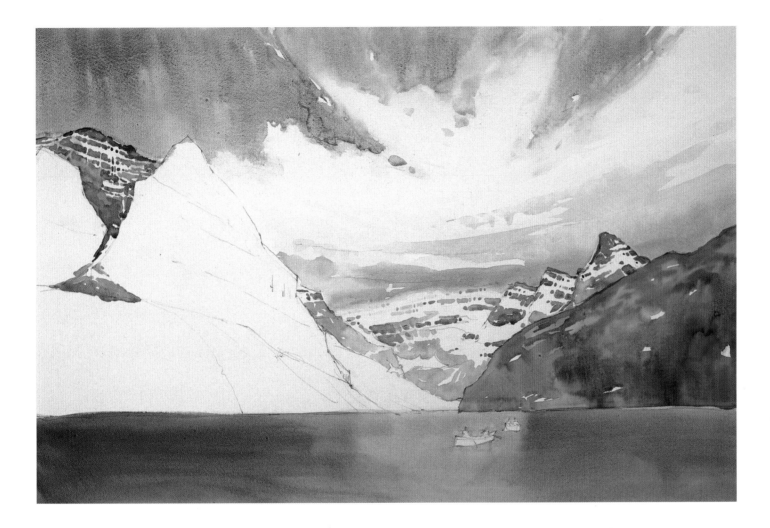

2 Begin Developing Mountains

With clean water in your no. 12 round, scrub and soften the area where the far mountains meet the sky, helping to create the illusion that the clouds are resting on the mountain tops. Then, with a very pale, cool gray mixture of Phthalo Violet, Ultramarine Blue and Cadmium Yellow Medium, paint over the far mountain to soften the snow patches. Still using the same brush, indicate exposed rock with combinations of Burnt Sienna, Ultramarine Blue and Phthalo Violet, adding dots and dashes of various sizes to suggest crevasses and light texture. Paint the snow and exposed rock on the mountaintop to the left using the same colors and techniques. Place some Sap Green and Burnt Sienna at the bottom of the slide area (the small gap between the two rocky mountains on the left) where vegetation begins. Then using your 1-inch (25mm) flat and clean water, wet down the mountain on the right, saving a few small white spaces on your paper. Mix and flow Burnt Sienna and Brown Madder into this wetness. While still damp, flow in variations of Ultramarine Blue, Phthalo Violet, Brown Madder and Burnt Sienna. Let your paper dry.

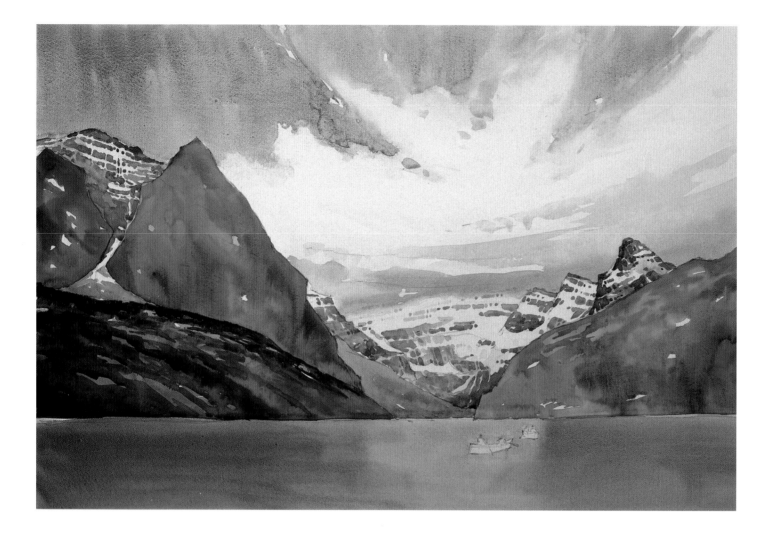

3 Define Grassy Terrain and Continue Developing Mountains

Using your no. 12 round, lay a mixture of Sap Green and Raw Sienna over the grassy lowlands between the mountains, dropping in touches of Burnt Sienna along the bottom to indicate dirt. Wet down the two large mountains on the left using clean water and your 1-inch (25mm) flat, being careful to save several small white spaces. Drop a mixture of Burnt Sienna and Brown Madder into the wetness. While still damp, flow in Ultramarine Blue and Phthalo Violet, allowing the colors to mix on your paper. Then using your no. 26 round and clean water, wet down the low foreground

mountain to the left and lay in Burnt Sienna. While wet, flow in Sap Green and Raw Sienna, followed by Ultramarine Blue, to indicate grasses. Be sure to vary values (emphasizing cool darks) and use rough strokes to define the slope and texture of the terrain. Model and darken the far mountains using your no. 12 round and a mixture of Burnt Sienna, Phthalo Violet and Ultramarine Blue. Suggest more vegetation at the base of the mountain on the left using your no. 8 round and Sap Green. Allow your paper to dry.

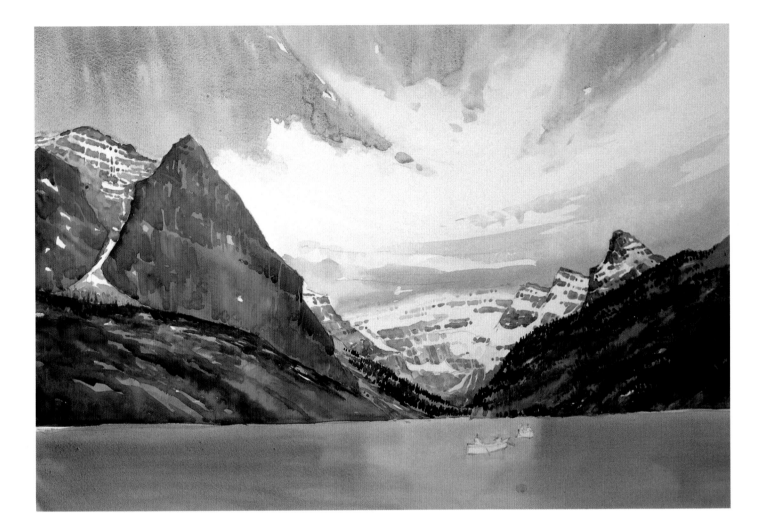

4 Suggest Trees

Add trees to the grassy lowlands between the mountains using your no. 12 round and various mixtures of Sap Green and Ultramarine Blue. Define the slope of the lowland with downward strokes using the same mixture with additional Ultramarine Blue. Add trees to the mountain on the right using your no. 3 fan blender and a cool green mixture of Ultramarine Blue and Sap Green. While still wet, flow in additional Ultramarine Blue for added dimension. Further develop the texture of the trees using the same colors and your no. 8 round. Then lay a pale wash of Ultramarine Blue over much of the upper right side of this area using your 1-inch (25mm) flat. This helps to subdue some of the warm patches, yet still allows warmth to remain near the center of the picture. Express vertical cracks and strata movement on the mountains to the left using your no. 26 round and a dark brown-violet mixture of Burnt Sienna, Ultramarine Blue and Phthalo Violet. Drop in Ultramarine Blue while still wet to darken and cool the area next to the slide. Use your no. 12 round with Sap Green to paint the bright green trees at the bottom of the slide area. Allow your paper to dry.

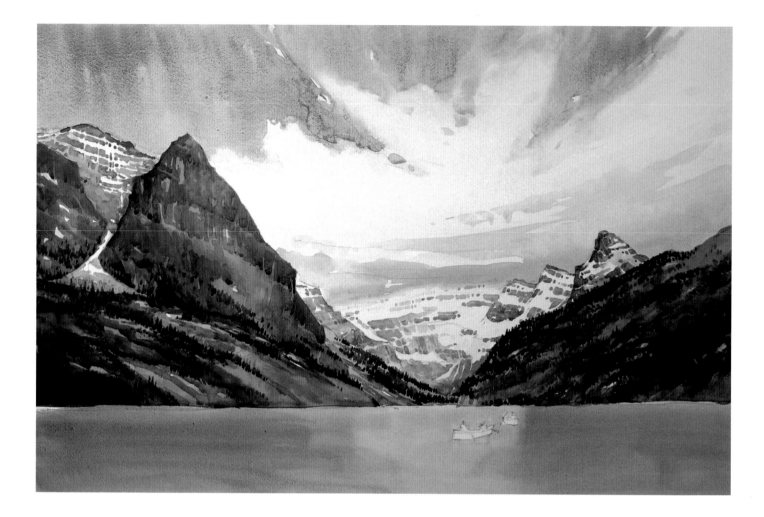

5 Add Darker Values and Details

Continue modeling the mountain on the left using your no. 12 round and a mixture of Burnt Sienna, Ultramarine Blue and Phthalo Violet. Then lay a darker mixture of Ultramarine Blue and Phthalo Violet over the area to the right of the slide to emphasize the gap, and drop in touches of Sap Green on the bottom of the mountain to indicate vegetation. Still using your no. 12 round, place quick, staccato strokes of Sap Green and Ultramarine Blue on the low foreground mountain to the left, suggesting trees. These trees should extend to the base of the larger mountains behind the grassy forefront mountain,

indicating the timber line. Place Cerulean Blue over some of the pure snow patches on the closer mountains to the left and right of the painting, softening and cooling the snow and creating shadows. Create a heavily forested area in the bottom left-hand corner of the low foreground mountain (just above the shoreline) using your no. 3 fan blender and a mixture of Sap Green and Ultramarine Blue. Add further detail to individual trees on both the left and right sides of the painting using your no. 12 round and Sap Green.

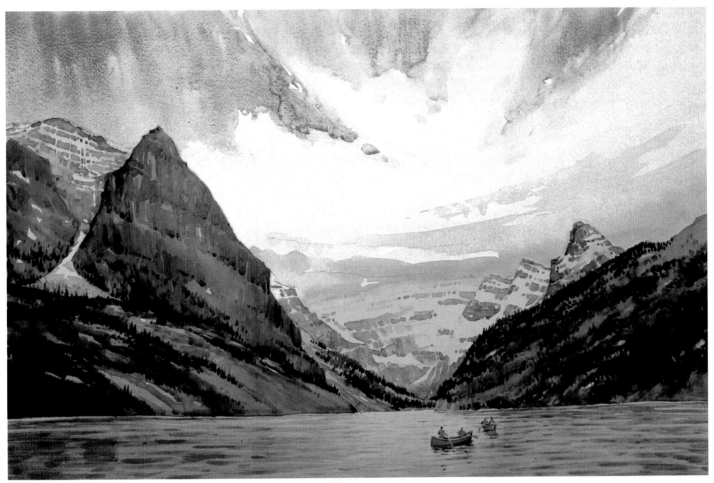

LAKE LOUISE
15" X 20" (38CM X 51CM)

6 Add Finishing Touches

Paint the canoes and life preservers using your no. 8 round and mixtures of Cadmium Red Light and Cadmium Yellow Medium, graying where needed with Ultramarine Blue. With the same brush and various combinations of Burnt Sienna, Brown Madder and Ultramarine Blue, paint the people and oars. Add texture to the water using your no. 12 round and mixtures of Cerulean Blue and Sap Green. Indicate reflections from the canoes using Ultramarine Blue and Brown Madder. With your no. 12 round and a mixture of Ultramarine Blue, Phthalo Violet and Burnt Sienna, add final texture to the mountains, establishing contrast where needed to create visual interest. If necessary, clean up the shoreline by lifting out any of the dark mountain color that may have overlapped into the water. To do this, simply scrub the dark areas with clean water in your no. 12 round and blot with a paper towel. Enhance the bottoms of the far mountains in the center of the picture with Phthalo Violet and Ultramarine Blue for contrast and richness. The high peak at top right should be subdued slightly with a wash of Phthalo Violet and Ultramarine Blue, creating separation between the far peaks. Slightly subdue the snow on the top left peak with the same harmonious color. Finally, using your no. 12 round and a mixture of Ultramarine Blue and Sap Green, darken the water on the right and left sides to draw the viewer's attention to the center of the lake.

DEMONSTRATION | MONUMENT VALLEY SAND DUNES

The breathtaking views of the American Southwest are nothing short of awe inspiring. The great wide open terrain bounded by steadfast rock formations creates a sense of calm, making one feel at once both free and protected. Painting this scene may be easy, but capturing the spirit and essence of the landscape is where the true challenge lies.

To create form and depth in this awesome scene required the proper use of value and placement of light and shadow. I used the sponge and wet-in-wet techniques to produce the soft and dramatic sky and the wet-on-dry technique to create the sharp and hard appearance of the rocks. I also applied the rules of aerial perspective, making the rocks softer and lighter as they receded, creating the illusion of distance.

Thumbnail Value Sketch

MATERIALS LIST

Surface	Crescent 114 watercolor board
Brushes	No. 3 hog-bristle fan blender
	Nos. 12 and 26 rounds
	1-inch (25mm) flat
Watercolors	Alizarin Crimson
	Brown Madder
	Burnt Sienna
	Cadmium Red Light
	Cadmium Yellow Medium
	Cerulean Blue
	Phthalo Violet
	Sap Green
	Ultramarine Blue
Other	Artificial sponge
	HB pencil
	Paper towels

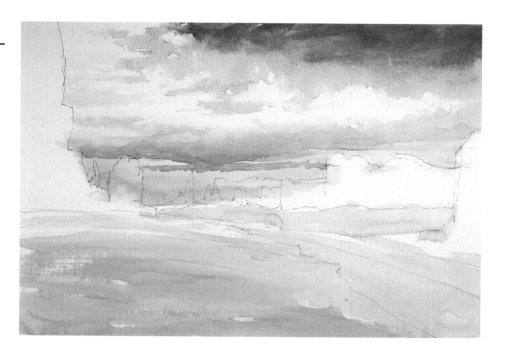

1 Lay in Sky and Foreground

After drawing with your HB pencil, apply clean water to the sky area using a sponge, tapping lightly so that some of the paper is left dry where the tops of the clouds will be. With your 1-inch (25mm) flat and Cadmium Yellow Medium and Cadmium Red Light, lay in a warm glow at the bottom of the sky, allowing it to fade and mix with the clean water as you move upward. With the same brush and a mixture of Cerulean Blue and Ultramarine Blue, flow more color into the wet area at the top of the sky, forming cloud tops around the dry areas. Use your no. 26 round and clean water to soften some of the hard edges. With the same brush and a mixture of Ultramarine Blue and Alizarin Crimson, paint in the bottoms of the clouds, keeping edges hard at the bottom and softening and losing the value as you move toward the tops of the clouds. Then using your 1-inch (25mm) flat and a mixture of Cadmium Yellow Medium, Brown Madder and a touch of Ultramarine Blue, paint in the foreground area to create the warm underpainting. Cool this slightly with Phthalo Violet. Allow your paper to dry.

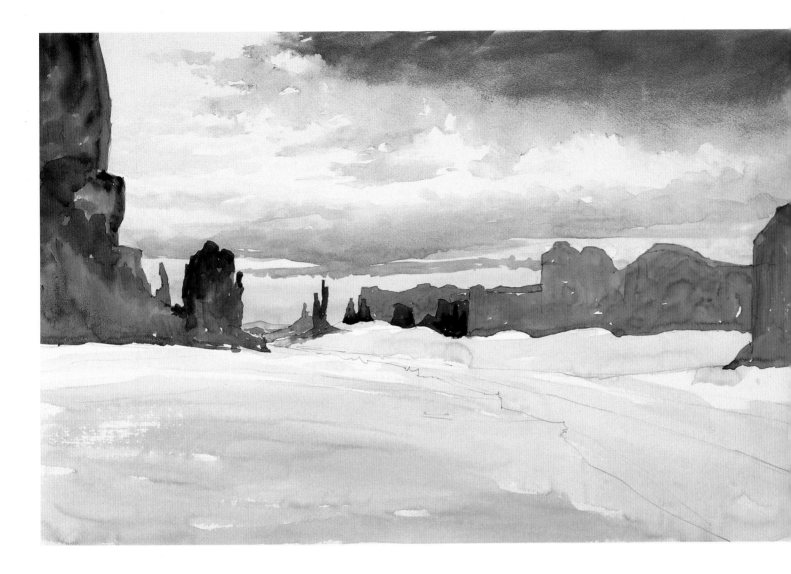

2 Paint Distant Mountains and Rock Formations

Using your no. 12 round and a mixture of Ultramarine Blue, Burnt Sienna and Phthalo Violet, lay in the distant mountains and rock formations. Paint the rocky mesa in the center of the composition using a darker mixture of the same colors. Then with your no. 26 round and a warm combination of Burnt Sienna, Brown Madder and Phthalo Violet, lay the initial wash on the rock formations to the right. Add Ultramarine Blue to darken and cool the existing mixture, and paint the rock formations on the left side using your no. 26 round. Add darker values into the wet areas to model and shape the rocks. Paint the small pinnacle-like rock formations at the center of the picture using your no. 12 round and a dark mixture of Ultramarine Blue, Phthalo Violet, Burnt Sienna and Brown Madder. Flow additional Ultramarine Blue into the wet shapes, creating interest and design. Keep the sand dunes in mind when painting the rock formations, creating the dune tops while painting the bottoms of the rock formation.

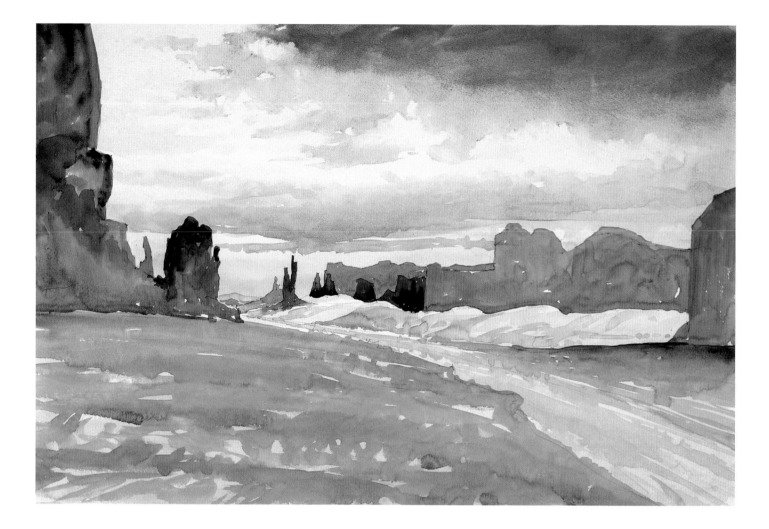

3 Lay in Sand Dunes and Dirt Road

Form and model the sand dune area in front of the darker rock formations using your no. 12 round and a mixture of Burnt Sienna, Cadmium Yellow Medium, Sap Green and Ultramarine Blue. Paint the dirt road to the right using the same brush and a warm mixture of Cadmium Yellow Medium, Burnt Sienna and Phthalo Violet. Still using your no. 12 round, lay in the slope to the right of the road with a mixture of Burnt Sienna, Sap Green and Ultramarine Blue. Next, lay in the foreground to the left of the road using your no. 26 round and a combination of Ultramarine Blue, Phthalo Violet, Sap Green and Burnt Sienna, allowing the greens to be concentrated at the most distant point in front of the tall, dark rock formations.

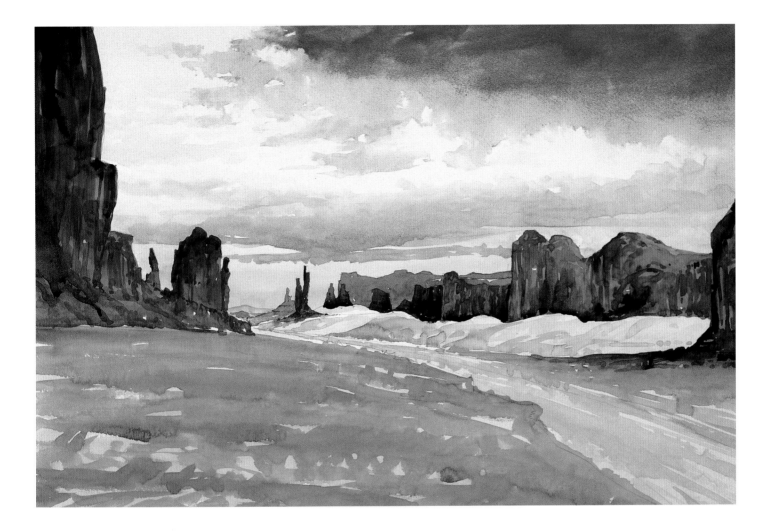

4 Add Definition and Texture to Rocks

With your no. 12 round and mixtures of Burnt Sienna, Ultramarine Blue, Brown Madder and Phthalo Violet, define the middle ground rock formations to the right. Use contrasting values to suggest the rough, sharp texture of the formations and create the illusion of depth. With the same brush and mixture, paint the large rock formation to the right, using vertical strokes to simulate the texture of weathered rocks. Repeat this process, adding darker detail and texture to the rock formations on the left. Add more Ultramarine Blue to the edges of the formations on both sides, creating contrast and preventing the warmer colors from leading the eye out of the picture.

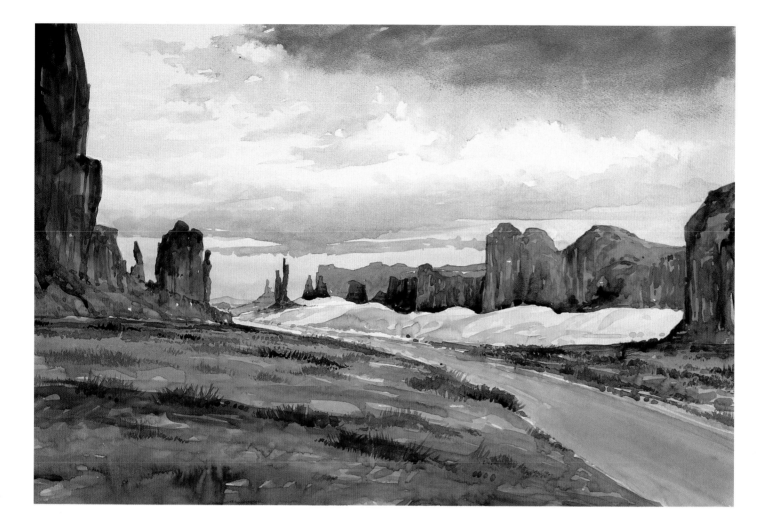

5 Place Darker Values and Grasses

Create a few light valued rocks at the base of the tall rocks on the left, lifting out rock shapes with your no. 12 round and clean water, then blotting with a paper towel. While still damp, lay a light wash of Burnt Sienna over these areas. Add shadows and dimension to the left foreground using your no. 26 round and a darker mixture of Ultramarine Blue, Burnt Sienna and Phthalo Violet. Repeat this process, modeling the area to the right side of the road using the same brush and mixture.

Paint sagebrush and grass on both sides of the road using your no. 3 fan blender and a mixture of Sap Green and Ultramarine Blue. Use vertical strokes to simulate the growth of the grasses. Lay a wash of Ultramarine Blue and Phthalo Violet where the rocks on the left meet the road, accenting the warmth of the road and the sand dunes. Then with your no. 12 round and a mixture of Burnt Sienna and Phthalo Violet, slightly darken the foreground of the road. Allow your paper to dry.

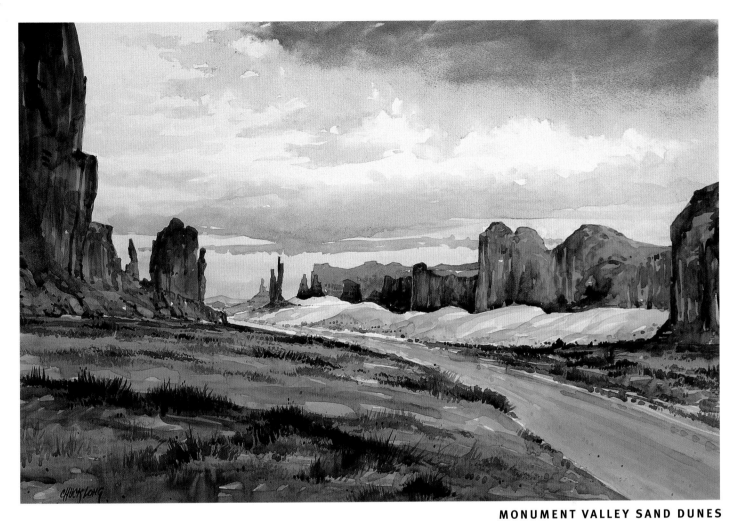

MONUMENT VALLEY SAND DUNES
15" X 20" (38CM X 51CM)

6 Add Finishing Touches

Further shape and model all rock formations, indicating cracks and crevasses with your no. 12 round and a mixture of Ultramarine Blue, Phthalo Violet and Burnt Sienna. Define the small debris at the base of these rocks using the same brush and colors. Add touches of Cerulean Blue to the far mesa to create more depth. Dot additional green sage at the bottom of the sand dunes and in the foreground areas using your no. 12 round and a darker mixture of Sap Green and Ultramarine Blue. Then simplify the rocks just to the right of center, scrubbing with clean water in your no. 12 round and allowing the paint to run together and resettle. Darken the sand dunes on the right using the same brush and a mixture of Ultramarine Blue, Burnt Sienna and Sap Green. This darkening helps to force the viewer's eye back toward the center of the painting. Add brown grass to the foreground using your no. 3 fan blender and a mixture of Burnt Sienna, Ultramarine Blue and Brown Madder. Lightly spatter the foreground using the same brush and a mixture of Burnt Sienna and Ultramarine Blue. Finally, paint textural streaks into the road using your no. 12 round and a lighter mixture of Ultramarine Blue and Burnt Sienna.

DEMONSTRATION | YOHO NATIONAL PARK

Named for its splendid scenery (*Yoho* means *magnificent* in the Cree language), Yoho National Park is a prime example of nature at its best. Lush forests, rumbling rivers and rocky banks set against a backdrop of majestic, ice-capped mountains make this an ideal setting for a watercolor masterpiece.

After using the wet-in-wet technique to lay in the cold and cloudy sky, I constructed the rest of the painting with a series of flat and graded washes, each new wash adding more depth and dimension to the scene. A hog-bristle fan blender worked perfectly for depicting tall tree shapes and texture and for spattering the rocks. I also used an artificial sponge to add further texture to the boulders in the foreground.

Thumbnail Value Sketch

MATERIALS LIST

Surface	Crescent 114 watercolor board
Brushes	No. 3 hog-bristle fan blender
	No. 3 rigger
	Nos. 8 and 12 rounds
	1-inch (25mm) flat
Watercolors	Alizarin Crimson
	Burnt Sienna
	Cadmium Yellow Medium
	Cerulean Blue
	Phthalo Violet
	Raw Sienna
	Sap Green
	Ultramarine Blue
Other	Artificial sponge
	HB pencil

1 Lay Initial Washes

After drawing with an HB pencil, wet down the sky with your sponge and some clean water. Using your 1-inch (25mm) flat and a gray mixture of Ultramarine Blue, Cerulean Blue, Alizarin Crimson and Cadmium Yellow Medium, lay in the sky color, being careful to leave pure white in sunny parts of the clouds. While still wet, lay in a mixture of Ultramarine Blue and Cerulean Blue to further darken the sky. Lay a light violet-gray (made from the same colors used for the sky) on the mountains to create the effect of shadows on snow. Still using your 1-inch (25mm) flat, lay a wash of Sap Green, Ultramarine Blue and Raw Sienna to suggest the water. Leave white spaces throughout to indicate the action of the water. Then paint initial washes over the foreground rocks using Burnt Sienna, Raw Sienna and Ultramarine Blue. Using your no. 3 fan blender and a mixture of Sap Green, Raw Sienna and Burnt Sienna, paint the foliage along the shoreline. Add touches of Burnt Sienna and Raw Sienna to indicate the ground and rocks above the river.

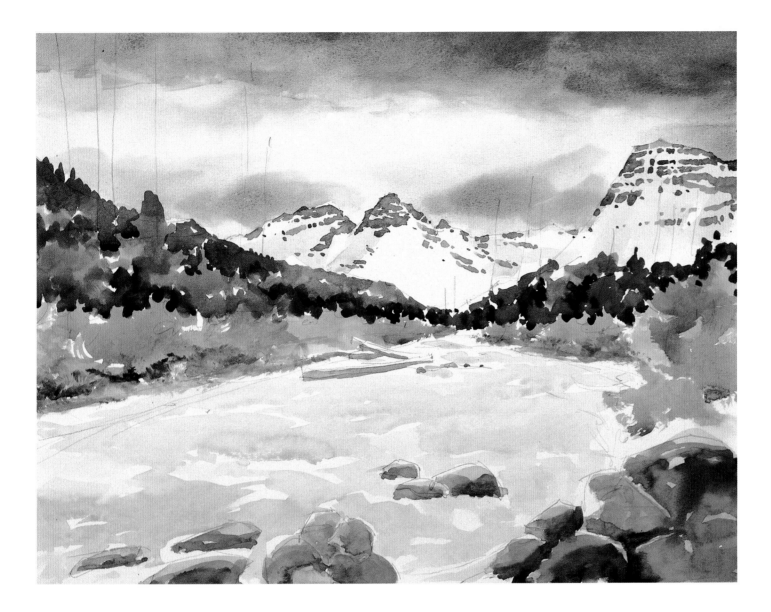

2 Begin Developing Rocks and Trees

Using your no. 12 round, lay a dark violet-gray wash of Ultramarine Blue, Burnt Sienna and Phthalo Violet on the distant mountain peaks to indicate rock showing through the snow. Shape and define the foreground rocks with washes of Burnt Sienna, Ultramarine Blue and Raw Sienna. Also suggest some rock and debris activity along the river bank using this mixture. Still using your no. 12 round, lay the initial washes for the far trees using mixtures of Sap Green, Raw Sienna and Ultramarine Blue. Let the brush wander with jerky movements and alternate values to suggest a forest of smaller trees.

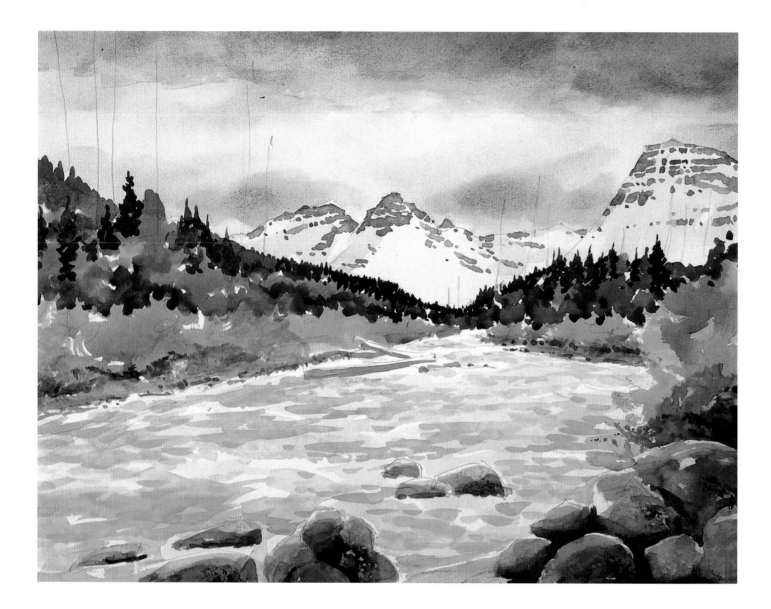

3 Suggest Movement in Water and Define Shoreline

Using your no. 12 round, shape and define the far trees with darker values of Sap Green mixed with Ultramarine Blue, giving vertical relief from the mostly horizontal direction. Darken the river bank at the shoreline, indicating more debris with mixtures of Raw Sienna and Sap Green. Create choppy water action with combinations of Raw Sienna, Ultramarine Blue, Sap Green and Cerulean Blue, being careful to save white water and slightly increasing the value as the water moves toward the foreground.

Add darks under the trees just above the foreground rocks using your no. 3 fan blender and a mixture of Raw Sienna and Sap Green followed by a darker mixture of Burnt Sienna and Ultramarine Blue. Use a sponge loaded with Burnt Sienna and Ultramarine Blue to create form and texture on the foreground rocks. With the same colors and your no. 12 round, paint in darks to suggest separation between rocks.

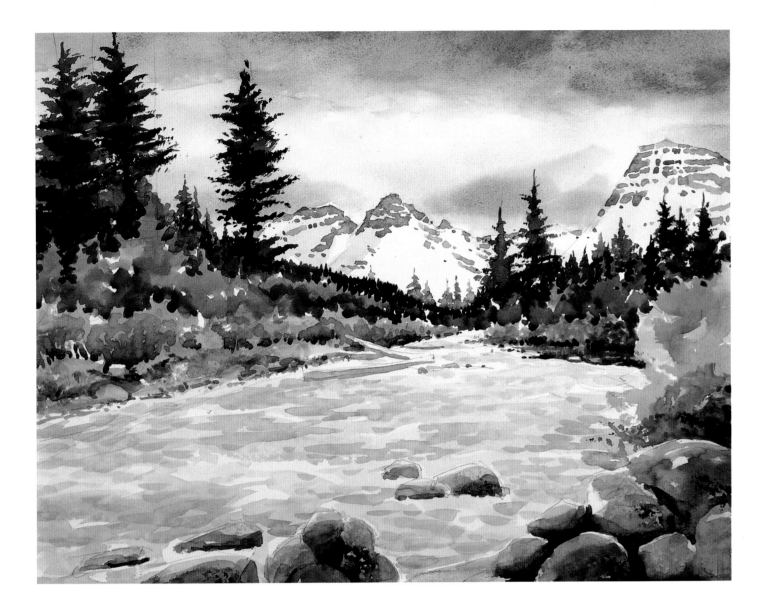

4 Paint Coniferous Trees

Render the large coniferous trees in the middle ground using your no. 3 fan blender and various mixtures of Sap Green, Ultramarine Blue and Burnt Sienna, defining the growth of the branches from the center outward. Lay in smaller, cooler and lighter trees behind these trees using your no. 12 round and a mixture of Sap Green and Ultramarine Blue. Develop smaller trees in front of the large trees using the same brush and a mixture of Sap Green and Raw Sienna. Add Ultramarine Blue to the mix to create the dark and cool shadows on these small trees. Create the distant coniferous trees with your no. 8 round and a mixture of Ultramarine Blue and Burnt Sienna. Use darker brown mixtures of Burnt Sienna grayed with Ultramarine Blue to create added depth to the riverbank area.

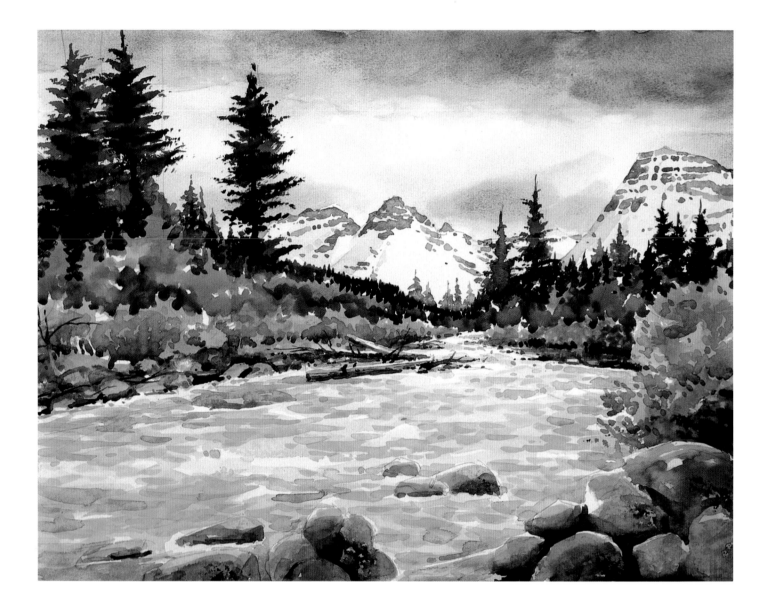

5 Add Further Detail

Add more texture and slightly darker values to the water action using your no. 12 round and a mixture of Ultramarine Blue and Sap Green. With the same brush, lay several warmer washes of Burnt Sienna into the cool grays of the far mountains, adding richness and lessening the monochromatic feel. Still using your no. 12 round, indicate cooler foliage in the foreground tree to the right with mixtures of Sap Green and Ultramarine Blue. Add

detail to the logs and driftwood at the center of the scene with your no. 3 rigger and a mixture of Burnt Sienna and Ultramarine Blue. With the same brush and color combination, paint more driftwood, debris and rocks on the left bank of the river. Then using your no. 8 round, lay a violet mixture of Phthalo Violet and Ultramarine Blue over the rocks to subdue their intensity.

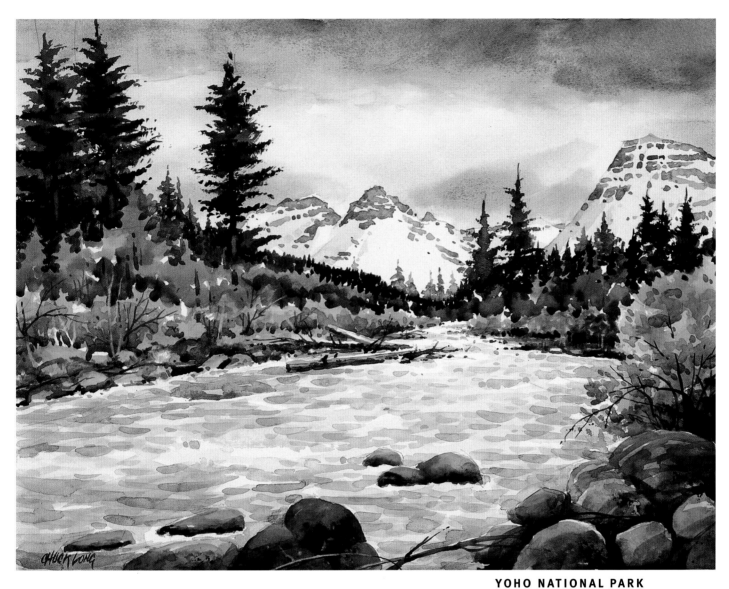

YOHO NATIONAL PARK
15" X 20" (38CM X 51CM)

6 Add Finishing Touches

Establish lighter, warmer trunks on the big trees at left, lifting out darks with clean water and your no. 8 round, then dropping in Burnt Sienna. Follow the same procedure to create vertical trunks and limbs in the smaller trees directly in front of the large trees. Next add limbs to the foreground trees on the right using a no. 3 rigger with Ultramarine Blue and Burnt Sienna. Cast darker values and violet shadows across the foreground rocks using your no. 12 round and a mixture of Phthalo Violet and Ultramarine Blue. This is done to subdue the rocks and to recall some of the violets from the background for color harmony. Using your no. 3 rigger and a mixture of Ultramarine Blue and Burnt Sienna, add limb debris to the rocks, connecting and unifying the rock masses. Using your no. 12 round, lay additional grayed washes of Ultramarine Blue and Sap Green into the foreground water to soften the scene and create a sense of depth.

DEMONSTRATION | NOVA SCOTIA FISHING VILLAGE

I n Nova Scotia, fishing isn't just a pastime, it's a way of life. Thus, villages like the one in this painting are commonplace. Despite the ubiquitous nature of these ports, though, they still possess innate beauty and quaint charm, making Nova Scotia a painter's paradise.

To depict the shacks and docks of this shoreside scene, I used both the wet-in-wet and wet-on-dry techniques. I developed realistic rock texture using sponge and spatter techniques, and suggested grasses with a fan brush. Graded washes were employed to show form and to create depth.

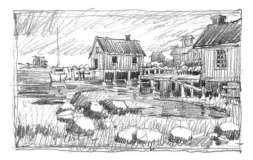

Thumbnail Value Sketch

MATERIALS LIST

Surface	300-lb. (640gsm) cold-pressed paper
Brushes	No. 3 hog-bristle fan blender
	No. 3 rigger
	Nos. 3, 8 and 12 rounds
	1-inch (25mm) flat
Watercolors	Brown Madder
	Burnt Sienna
	Cadmium Red Light
	Cadmium Yellow Medium
	Cerulean Blue
	Davy's Gray
	Indigo Blue
	Phthalo Violet
	Raw Sienna
	Sap Green
	Ultramarine Blue
Other	Artificial sponge
	HB pencil

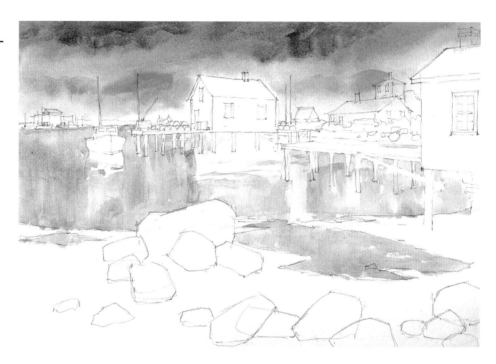

1 Lay in the Sky and Water

Draw key guidelines on your paper with an HB pencil. Make your lines dark enough so they don't get lost when you start painting. Next, wet down the sky using your 1-inch (25mm) flat and clean water. Lay a mixture of Ultramarine Blue and Davy's Gray into the wetness, covering the sky with a light, uniform gray. Flow in additional Ultramarine Blue to define darker areas in the clouds, contrasting with the uniform sky and suggesting form. Still using your 1-inch (25mm) flat, add a touch of Sap Green to the sky mixture and lay in the water area of the picture. Be sure to leave the beginnings of some reflections to be developed later. Let your paper dry.

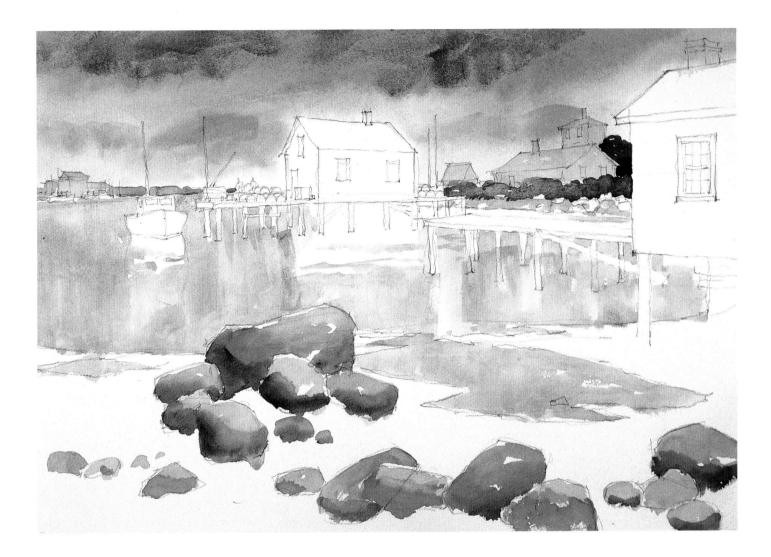

2 Begin Background and Develop Foreground Rocks

Using your no. 12 round, lay a light mixture of Ultramarine Blue and Phthalo Violet over the buildings in the distant right. Paint the buildings in the distant left using the same brush and mixture. Add Burnt Sienna to the mixture and paint the bank and rocks just below the buildings on the right. Create the green shrubs just above this bank using a mixture of Sap Green, Ultramarine Blue and Burnt Sienna. Paint the distant tree above these shrubs with a cooled gray-green for depth. Indicate the land in the distant left with a mixture of Sap Green and Ultramarine Blue. While the background dries, rough in the rocks in the foreground using a combination of Burnt Sienna and Ultramarine Blue, letting the blues become cool shadows on the rocks.

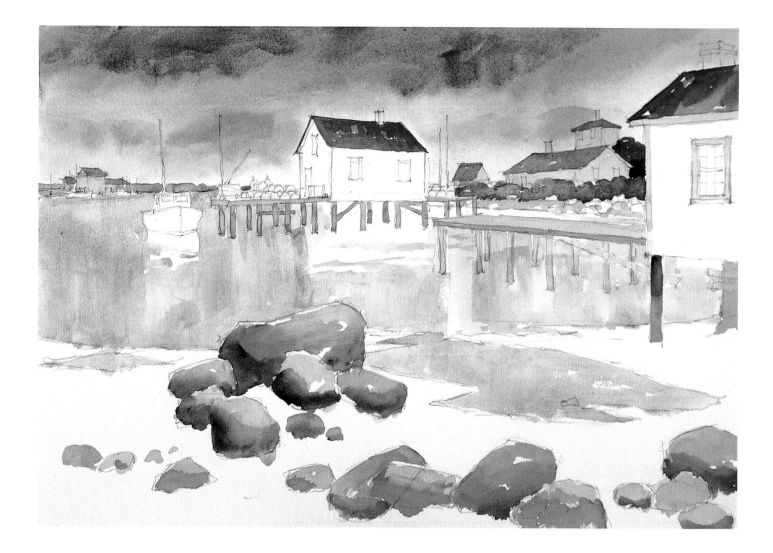

3 Paint the Roofs and Docks

Still using your no. 12 round, paint the roofs of all the buildings with a mixture of Ultramarine Blue and Brown Madder, varying the color and value of each roof to create interest and suggest depth. Take care to leave some whites on the roofs for highlights. Indicate the trim on the building at far right using a neutral gray made from Burnt Sienna and Ultramarine Blue. Warm the gray, adding more Burnt Sienna, and paint the docks and piers. Add Cadmium Yellow Medium and more Burnt Sienna to this mixture, and lay in some of the underpinnings of the building on the far right. Darken the side plane of the closest dock and the corner pier of the building on the far right using your no. 8 round and a combination of Burnt Sienna, Phthalo Violet and Ultramarine Blue, allowing the colors to mix while still wet. Let your paper dry.

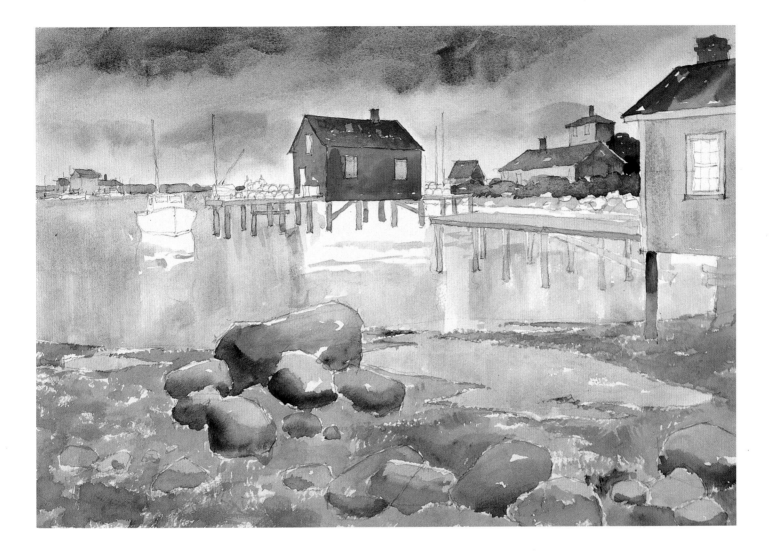

4 Paint Fishing Shacks and Foreground Grasses

Lay a wash of Cerulean Blue over the building on the far right using your no. 12 round. While still wet, add Raw Sienna, warming the color as the building goes out of the picture. Next, lay a brownish red wash of Cadmium Red Light and Raw Sienna over the front of the center building. While this wash is still wet, drop in a small amount of Cerulean Blue at the bottom. With the same red and sienna mixture, lay a wash over the side of the center shack, dropping in touches of Phthalo Violet while the wash is still wet. Add the sky reflections on the windows of this building using your no. 3 round and Cerulean Blue. Paint all the chimneys with your no. 8 round and a mixture of Brown Madder, Burnt Sienna and Ultramarine Blue. With the same brush, darken the sides of the small buildings in the distant right with Raw Sienna and Ultramarine Blue. While the buildings dry, paint the dead grass and seaweed in the foreground using your no. 3 fan blender and mixtures of Raw Sienna, Burnt Sienna, Ultramarine Blue and Phthalo Violet. Be sure to vary the color and value of the grasses to indicate light and shadow, and leave whites for highlights. Let your paper dry.

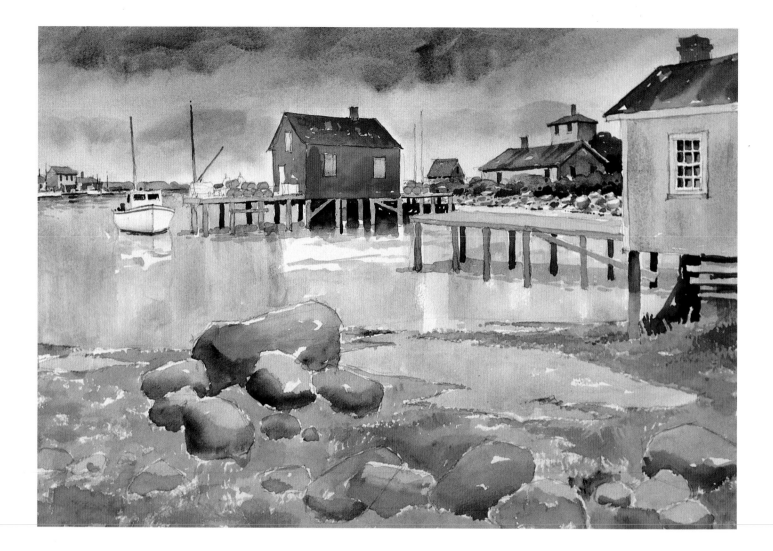

5 Add Further Details

Paint the window panes on the building on the far right using your no. 8 round and a mixture of Indigo Blue and Burnt Sienna. With the same brush and mixture, create activity under the shack, painting dark shadows behind the lighter foundation boards. Add some detail and depth to the rocky bank in the distant right using your no. 3 round and a mixture of Ultramarine Blue and Burnt Sienna. Darken the shrubs on the distant bank, adding more Sap Green to suggest shape and separation. Indicate dark piers under the docks using your no. 8 round and a mixture of Ultramarine Blue and Burnt Sienna. With the same brush and mixture, paint the shadows under the center building. Use a pale mixture of Sap Green and Ultramarine Blue to paint the shadows on the water beneath the docks. Lay a light, warm wash of Raw Sienna and Ultramarine Blue over the lobster traps on the docks using your no. 3 round. Add details to the buildings, docks and water in the distant left using the same brush and various cool grays made of Ultramarine Blue and Burnt Sienna. Paint the large boat using the existing grays and Brown Madder for the water line. Allow your paper to dry.

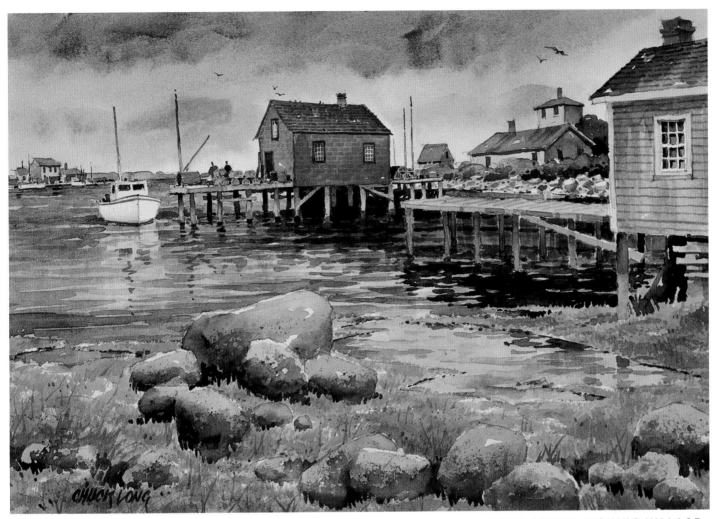

NOVA SCOTIA FISHING VILLAGE
15" X 22" (38CM X 51CM)

6 Add Finishing Touches

Using your no. 3 round and various gray mixtures of Ultramarine Blue, Brown Madder and Burnt Sienna, detail the windows, shingles and siding of the center building. Add dock activity using Cerulean Blue, Sap Green, Ultramarine Blue and Burnt Sienna. Place reflections on the water using your no. 12 round and all of the colors being reflected from the buildings, docks, boats and so on. Be sure to make these reflections darker and grayer than the actual objects. Continue modeling the closest dock, darkening the piers and indicating the boards on top with your no. 3 round and a mixture of Burnt Sienna and Ultramarine Blue. Paint the shadow under the roof and add clapboard texture to the building on the far right using your

no. 8 round and a mixture of Ultramarine Blue and Burnt Sienna. Then add texture to the shingles using a dark mixture of Ultramarine Blue and Brown Madder. Create streaking on the clapboard to show weathering using your no. 8 round and a mixture of Ultramarine Blue and Sap Green. Add more shape and texture to the foreground rocks using your artificial sponge and mixtures of Ultramarine Blue and Burnt Sienna. Add touches of Ultramarine Blue and Phthalo Violet at the bottom of the rocks to indicate shadowed areas of grass. Create additional grass texture using your no. 3 fan blender and mixtures of Raw Sienna, Burnt Sienna, Ultramarine Blue and Phthalo Violet. Use your no. 3 rigger to suggest individual grass strokes.

DEMONSTRATION | GLACIER NATIONAL PARK

Another source of overwhelming beauty in the Canadian Rockies, Glacier National Park is filled with some of the most picturesque panoramas in the world. Tourists come from great distances throughout spring and summer to marvel at the sights Glacier has to offer, but it was this dramatic view of Logan Pass in the heart of winter that most intrigued me. You can almost feel the cold sting in the air just looking at this scene!

The upper-half of this painting required an extremely wet technique, laying successive wet washes into already wet paper. As the scene comes toward the viewer, though, the edges get harder and come into focus. I used the wet-on-dry technique to depict these sharper images and to layer for depth. I roughed in grass and moss using a hog-bristle fan blender, making good use of negative space in these areas to create the appearance of actual chunks or blades of grass.

Thumbnail Value Sketch

MATERIALS LIST

Surface	Crescent 114 watercolor board
Brushes	No. 3 hog-bristle fan blender
	Nos. 8, 12 and 26 rounds
	1-inch (25mm) flat
Watercolors	Brown Madder
	Burnt Sienna
	Cadmium Yellow Medium
	Cerulean Blue
	Phthalo Violet
	Raw Sienna
	Sap Green
	Ultramarine Blue
Other	HB pencil
	Paper towels

1 Lay in Sky

After drawing with your HB pencil, wet down the sky with clean water and your 1-inch (25mm) flat. Extend the wetness to the tops of the middle ground mountains. Lay a slightly greenish yellow mixture of Cadmium Yellow Medium and Ultramarine Blue into the lower part of the sky, allowing the color to fade as it moves upward. The fading is accomplished by not renewing the pigment and letting the surface water dilute the color. Then with a mixture of Ultramarine Blue, Raw Sienna and Brown Madder, add thick horizontal strokes to darken the sky. Repeat this process using a darker version of the same mixture.

2 Paint the Mountains

Lay in the far mountain using your no. 26 round and a mixture of Ultramarine Blue, Burnt Sienna and Phthalo Violet. Place the darkest values at the base of the mountain, gradually lightening the color as you move toward the top. While still wet, soften some of the peaks using clean water and your no. 26 round, blending the peaks into the clouds. Then using your no. 12 round, paint a pale blue mixture of Ultramarine Blue and Cerulean Blue over the mountains to the left and right (this light color will later represent patches of snow). With the same brush use quick downward strokes to lay a wet mixture of Ultramarine

Blue, Burnt Sienna and Sap Green on the mountain to the right, carefully painting around portions of the mountain to indicate patches of snow. Use choppy, short strokes near the peak, creating the illusion of atmospheric haze. The mountaintop should look as though it disappears into the clouds, so soften with clean water and your no. 12 round if necessary. Paint the mountain on the left using the same mixture and technique, stopping at the tree line. Since this mountain is closer to the viewer, add more Sap Green to the base to pull the mountain forward. Allow your paper to dry.

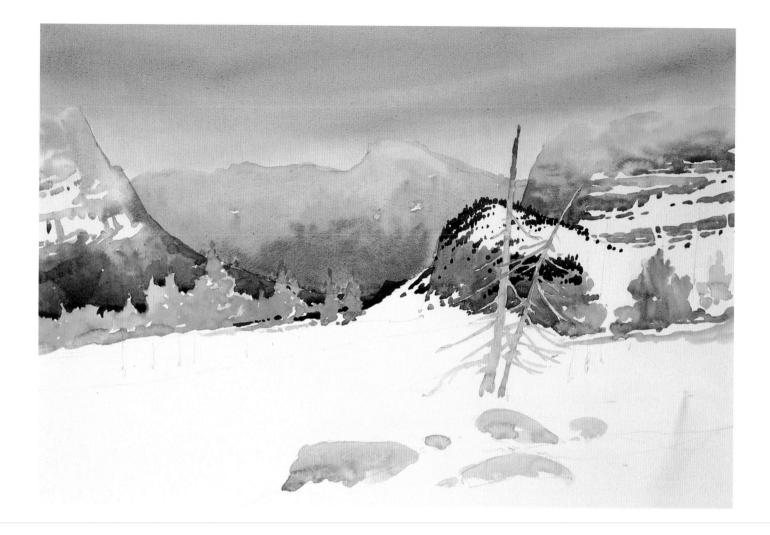

3 Add Foliage and Foreground Rocks

Paint in the two dead trees to the right of center using your no. 12 round and a mixture of Burnt Sienna, Ultramarine Blue and Cadmium Yellow Medium. Using the same brush, paint the foliage to the left with a mixture of Cadmium Yellow Medium, Burnt Sienna and Brown Madder. Use this mixture to indicate the foliage on the right as well, creating a sense of balance. Using your no. 8 round and Brown Madder followed by Ultramarine Blue, paint the side of the mountain behind the two dead trees, allowing the colors to mix on your paper. Dot in the trees on this mountain using your no. 12 round and a mixture of Ultramarine Blue, Sap Green and Burnt Sienna, being careful to save whites to suggest fallen snow. Using the same brush and mixture, add dark values beneath the foliage slightly left of center. Rough in the rocks in the foreground using a mixture of Ultramarine Blue and Burnt Sienna.

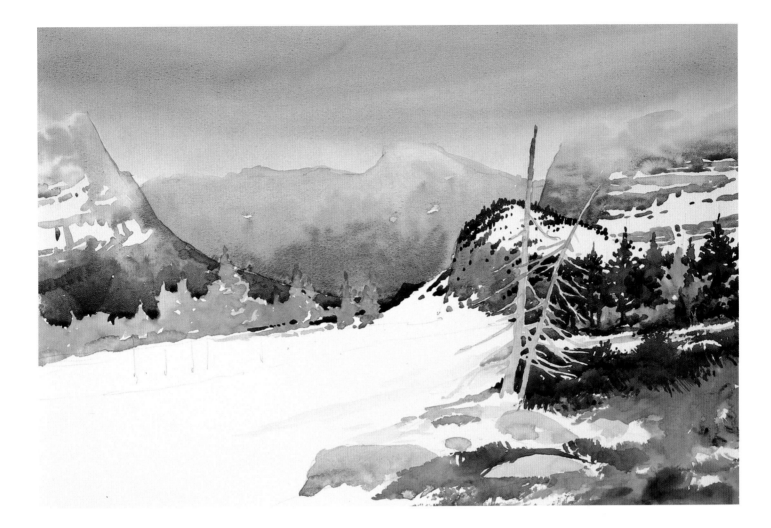

4 Suggest Grass and Coniferous Trees

Rough in the dead grass in the bottom right-hand corner using your no. 3 fan blender and mixtures of Burnt Sienna, Ultramarine Blue and Sap Green. Once again, save some whites to indicate fallen snow. Suggest small patches of living grass around one of the foreground rocks using the same brush and Sap Green mixed with clean water. Still using your fan blender, lay in dark green moss above the dead grass with a mixture of Sap Green and Ultramarine Blue. Slightly pull the moss into the dead grass where the two areas meet, creating the illusion of actual blades and chunks of dead grass. Add the coniferous trees above this area using your no. 12 round loaded with a dark mixture of Sap Green and Ultramarine Blue. Because the two dead trees in front of these conifers serve as the painting's center of interest, carefully lay darks around the limbs of the dead trees to avoid obscuring them. Subdue some of the whites in this area with a pale wash of Cerulean Blue, using slightly darker mixtures to suggest shadows and drifts in the snow.

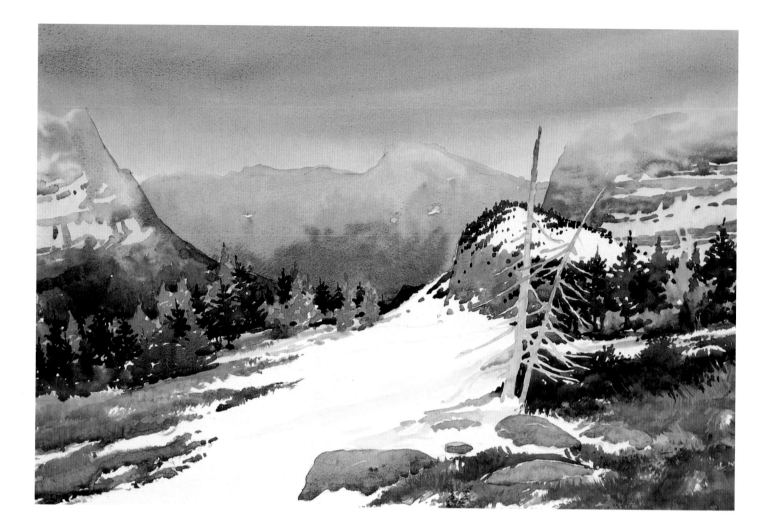

5 Add Darker Values and Texture

Add darker values to the trees on the left side of the painting using your no. 12 round and a mixture of Burnt Sienna and Brown Madder. These reddish brown trees should appear solid and round rather than flat. Place several green trees among the reddish brown trees using your no. 12 round and a mixture of Ultramarine Blue and Sap Green. Allow some of the red-brown to show through the green trees, creating a sense of depth. Add touches of Cerulean Blue to the snow beneath these trees to suggest small drifts. Next paint the dead grass on the left with your no. 3 fan blender and Raw Sienna, Burnt Sienna, Sap Green and Ultramarine Blue. Add textural strokes to the grass while the paint is still wet, and leave patches of snow showing through. Darken and develop the foreground rocks using your no. 12 round loaded with Ultramarine Blue and Burnt Sienna. Then darken the lower right-hand corner of the painting, adding texture to the grass using your no. 3 fan blender and a mixture of Burnt Sienna, Ultramarine Blue and Phthalo Violet.

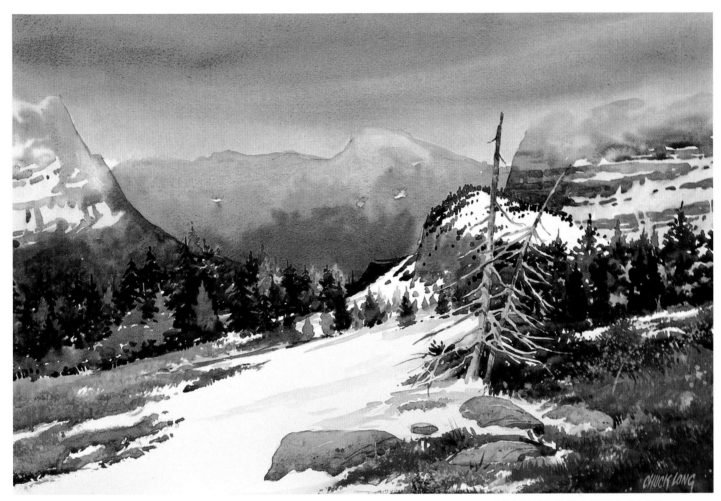

GLACIER NATIONAL PARK
15" X 20" (38CM X 51CM)

6 Add Finishing Touches

Using your no. 12 round, add Ultramarine Blue to the bottom of the mountain on the left to give the illusion of greater depth. Further define the strata on the small mountain behind the dead trees using your no. 8 round and a mixture of Burnt Sienna and Ultramarine Blue. Simplify the painting, toning down the reddish brown trees on the left with washes of Ultramarine Blue. Also add dark Sap Green over parts of these trees to lessen the abundance of warm hues. Doing so ensures that this portion of the painting won't compete with the dominant element (the two dead trees) for the viewer's attention. Still using your no. 8 round, further refine the dead trees with a mixture of Ultramarine Blue and Burnt Sienna,

darkening some limbs to create stronger contrast with the background. Add shadows on the trunks and limbs with a mixture of Phthalo Violet and Ultramarine Blue. Next, cool some of the browns in the lower right-hand corner using your no. 3 fan blender and a mixture of Ultramarine Blue and Phthalo Violet. Using the same brush, add extra texture to the foreground foliage, spattering with clean water then lightly lifting out color with a paper towel. Finally, add several smaller trees to the center of the picture to make the mountains recede further in the distance using your no. 8 round and various combinations of Sap Green, Ultramarine Blue and Raw Sienna.

DEMONSTRATION | HONFLEUR INNER HARBOR

This architecturally detailed painting requires a lot of planning, drawing and preparation. In a medieval town like this, there are few lines that are square and plumb, making it all the more complex. Fortunately, the intricate details of the structures in this old town are part of its unique charm.

Masking is crucial for such a detailed painting. Though I utilized both wet-in-wet and wet-on-dry techniques, a great deal of this demonstration was completed with straightforward painting: laying flat and graded washes and layering to create depth and reflective quality.

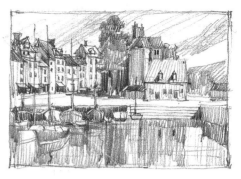

Thumbnail Value Sketch

MATERIALS LIST

Surface	Crescent 114 watercolor board
Brushes	Nos. 3, 8, 12 and 26 rounds
	Old round brush (preferably a no. 3)
	1-inch (25mm) flat
Watercolors	Alizarin Crimson
	Brown Madder
	Burnt Sienna
	Cadmium Red Light
	Cadmium Yellow Medium
	Cerulean Blue
	Payne's Gray
	Phthalo Blue
	Phthalo Violet
	Raw Sienna
	Sap Green
	Ultramarine Blue
Other	HB pencil
	Masking fluid
	Masking tape
	Tracing paper

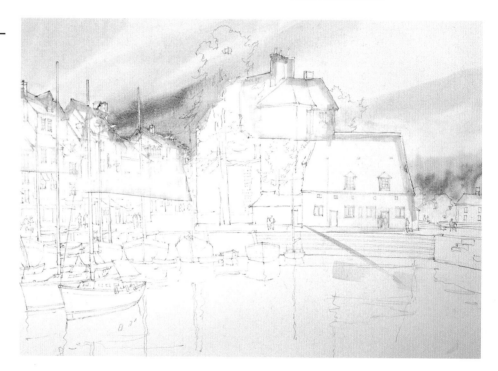

1 Lay in Sky

After carefully drawing with your HB pencil, mask off the silhouette of the rooflines using masking fluid and an old brush. A width of approximately ¼-inch (6mm) should be sufficient. Place a piece of tracing paper (roughly cut to the shape of the silhouette of the buildings) next to the masked line, and secure this with masking tape. Then wet down the sky area with clean water and your 1-inch (25mm) flat. Make a yellowish orange wash with Cadmium Yellow Medium and Alizarin Crimson, and flow this into the wetness in the bottom part of the sky. This gives a warm base for the clouds. Create the clouds with a mixture of Cerulean Blue and Ultramarine Blue, sweeping your 1-inch (25mm) flat in a diagonal direction.

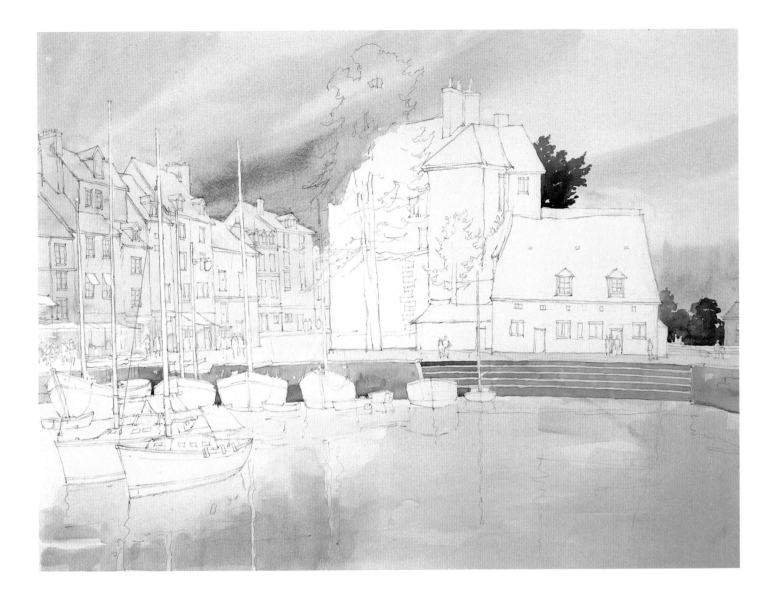

2 Remove Masking and Lay Initial Washes

Remove all masking from your paper. Paint the initial washes over the buildings on the left using your no. 12 round and a pale gray mixture of Phthalo Blue, Alizarin Crimson and Cadmium Yellow Medium. Allow the grays to move from cool to warm by adding more red or yellow as you progress. Leave a few pure whites for highlights. Paint in the building at the far right using the same technique. Rough in the trees behind the center building and to the right using your no. 12 round and a mixture of Ultramarine Blue, Sap Green and Alizarin Crimson. Lay a warm wash of Phthalo Blue, Alizarin Crimson and Cadmium Yellow

Medium over the steps and horizontal walkways between the harbor and the buildings using the same brush. With a mixture of Phthalo Violet, Ultramarine Blue and Burnt Sienna, place grays in the darker verticals of the quay walls and planes of the steps. Lay the initial wash for the foreground water using your 1-inch (25mm) flat and warm and cool mixtures of Ultramarine Blue, Alizarin Crimson and Cadmium Yellow Medium. Paint those portions of the water that reflect the sky using the same brush and some of the blue mixture left over from the sky.

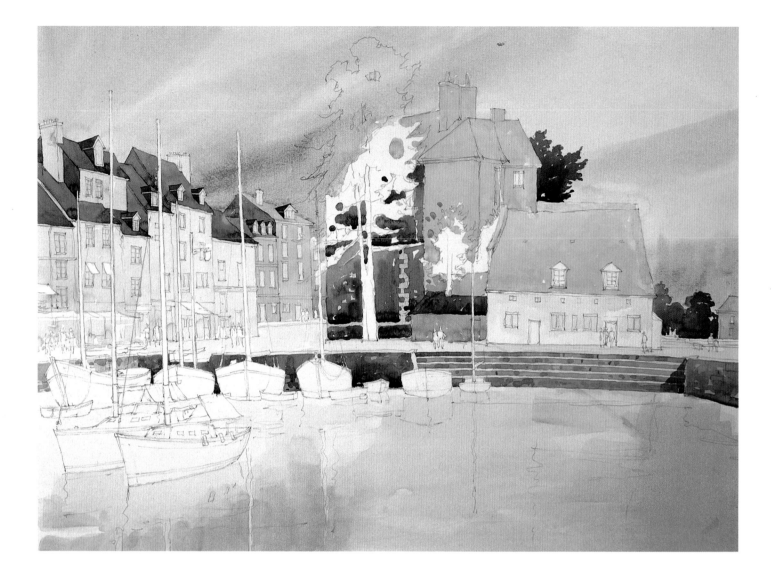

3 Begin Developing Buildings

Using your no. 12 round and a cool gray mixture of Ultramarine Blue and Burnt Sienna, lay a wash over the wall to the lower right of the center building. Paint over most of the center building and the roof of the building to the right using the same brush and a mixture of Cadmium Yellow Medium, Burnt Sienna and a touch of Ultramarine Blue. Mix a darker, warmer gray using Phthalo Violet, Ultramarine Blue and Burnt Sienna to paint the lower portion of the building at exact center. With the same colors, make a darker gray wash and lay it over the left vertical side of the center building, painting around some windows, stone quoins and the large tree in the center. Then, paint the quay walls and steps using your no. 8 round and combinations of Burnt Sienna, Ultramarine Blue and

Phthalo Violet, taking care to indicate light and shadow. Use a no. 8 round with various mixtures of Ultramarine Blue, Burnt Sienna and Phthalo Violet to indicate the roofs and dormers on the buildings to the left. Use a mixture of Cadmium Yellow Medium, Phthalo Violet and Cadmium Red Light to paint in the facades and roofs of the building to the right of center. Paint the roof of the low building at the center of the composition using your no. 12 round and a combination of Ultramarine Blue and Burnt Sienna. Lay in the Burnt Sienna first, then flow the Ultramarine Blue into the brown, allowing the colors to mix on the paper. Let your paper dry.

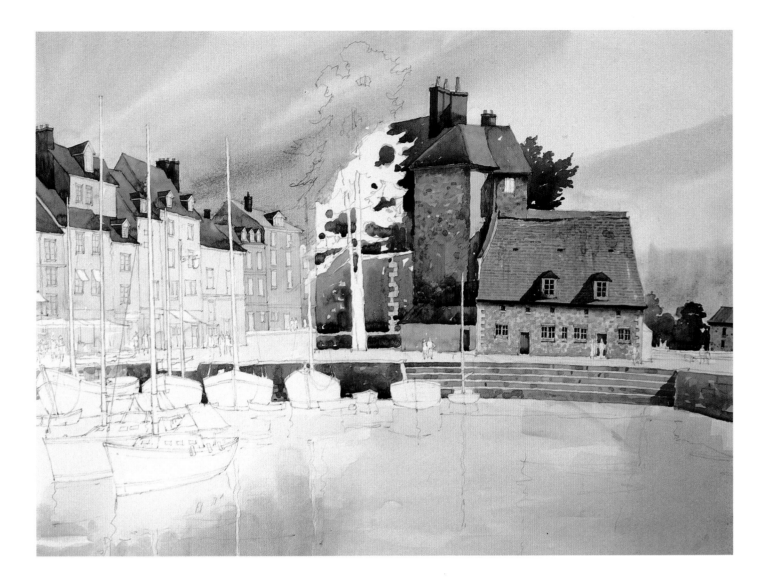

4 Further Refine Buildings

Form all chimneys using your no. 8 round and various mixtures of Brown Madder, Burnt Sienna and Ultramarine Blue. With your no. 26 round and a medium-value mixture of Burnt Sienna, Cadmium Yellow Medium, Cadmium Red Light and Ultramarine Blue, lay a wash over the roof of the center building. Paint the shaded areas with the same mixture darkened with Ultramarine Blue, Phthalo Violet and Raw Sienna, punching in deep shadows with additional pigment. Carefully preserve the bright sunny spots for maximum sunlight and shadow effects. Use the same brush and colors to paint the large roof on the shorter building directly right of center. Then with your no. 8 round and the same mixture slightly darkened with more Raw Sienna, place directional strokes on this roof to indicate the shingles. Lay a cool gray mixture of Burnt Sienna

and Ultramarine Blue over the stone lintels, door frames, windows and the quoins at corners, as well as to the walls of the building directly to the right of the center building. Follow this with a warm wash (made of the same colors) over the entire stone wall. Suggest the texture of the stone walls using your no. 3 round and additional Burnt Sienna and Ultramarine Blue. Add window detail using the same brush and colors. Paint the doors with Brown Madder, using Ultramarine Blue for the shadows. Add a dark shadow under the roof and to the left of the the dormers using your no. 3 round and a mixture of Burnt Sienna, Phthalo Violet and Ultramarine Blue. Paint the building at the far right with the same colors used to paint previous buildings. Let your paper dry.

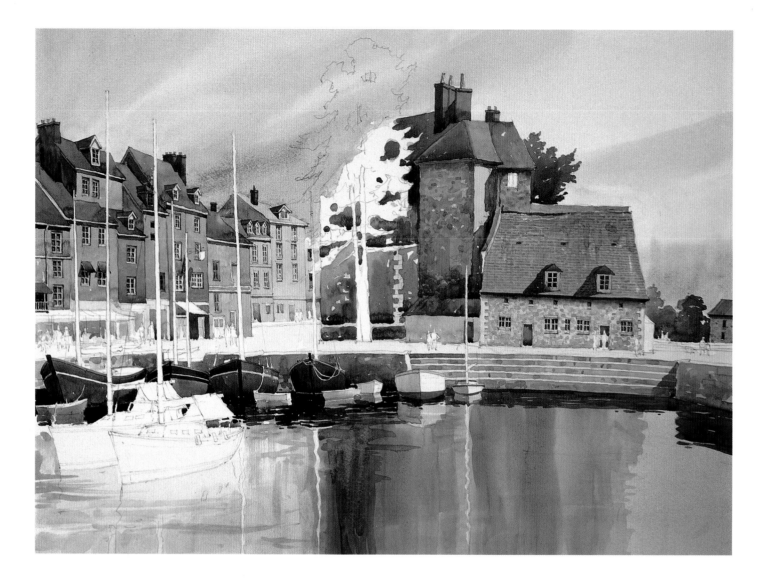

5 Paint Boats and Detail the Water

Using your no. 8 round and various combinations of Ultramarine Blue and Raw Sienna, lay in the fronts of all the buildings on the left. Use your no. 3 round to paint around the boat masts. Paint in window detail with a mixture of Ultramarine Blue, Burnt Sienna and, at times, Raw Sienna. Place a cool gray cast shadow made from a mixture of Ultramarine Blue, Phthalo Violet and Burnt Sienna under the roof eaves. Lay in the blue and red canopies and then add their cast shadows using Cadmium Red Light and Cadmium Yellow Medium. Paint reflections in the water using your no. 26 round and mixtures of Ultramarine Blue, Burnt Sienna, Phthalo Violet, Alizarin Crimson, Cadmium Yellow Medium and Sap Green, making vertical and wiggly strokes. Paint the boats at center with a gray made from Ultramarine Blue and Raw Sienna for the shadows, and leave white paper

for whites. Paint the boat bottoms using your no. 8 round and a mixture of Ultramarine Blue and Brown Madder. Place the dark reflections around the boats using your no. 12 round and a mixture of Ultramarine Blue, Burnt Sienna and Phthalo Violet. With your no. 8 brush, paint the green boats with Sap Green and Ultramarine Blue, adding Cadmium Yellow Medium for the yellow-green boat. Paint the dinghies with Ultramarine Blue and Raw Sienna. Lay darker reflections of the dinghies into the water using the same colors. Paint the blue boat with Ultramarine Blue, adding Sap Green and Payne's Gray for the blue-green boat. Still using your no. 8 round, paint the quay reflections in the water with combinations of Ultramarine Blue, Burnt Sienna, Sap Green and Payne's Gray. Add the gunwales using a mixture of Raw Sienna and Burnt Sienna.

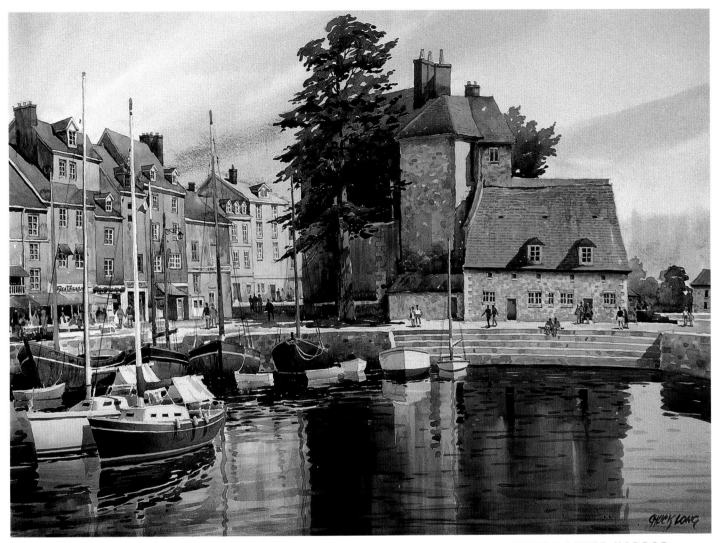

HONFLEUR INNER HARBOR
15" X 20" (38CM X 51CM)

6 Add Finishing Touches

With your no. 3 round, detail the windows and texture the roof and stone walls of the large buildings at center. Then paint the tree with your no. 12 round and a mixture of Sap Green, Ultramarine Blue and Burnt Sienna for foliage, and Phthalo Violet, Burnt Sienna and Ultramarine Blue for the trunk. Create smaller limbs with your no. 8 round. Using your no. 3 round, lay in the sidewalk café to the left. Use mixes of Cadmium Yellow Medium, Alizarin Crimson and Cerulean Blue for the canopies. Paint the silhouettes of people with reds, yellows, blues and greens, using Burnt Sienna for the flesh. Daub in darker blue-grays around the silhouettes to suggest unexplained activity, and paint people in the distant background in a similar fashion. Paint the flag, lantern, flowers and signs to add color. Shape the lower part of the white boat in the foreground using your no. 8 round and a pale wash of Raw Sienna and

Ultramarine Blue, fading to a pure white at the top of the hull. Paint in the colored stripes at the waterline using Cadmium Red Light, Cadmium Yellow Medium and Sap Green, and reflect these in the water. With the same brush and a mixture of Ultramarine Blue and Sap Green, paint the green hull, working from stern to bow and adding more of the blue and green as it is darkened. Add colored stripes at the waterline using your no. 3 round and Cadmium Yellow Medium and Burnt Sienna. The reflections of the boats in the water should give a feeling of undulating ripples. Indicate mast reflections as well, letting the lines distort in the water. Apply additional washes of cool grays made from Ultramarine Blue and Burnt Sienna to the buildings on the left, showing discoloration and age. Paint the people from center to right, along with the steps to the right of the shorter building.

DEMONSTRATION | A STREET IN DINAN, FRANCE

Who can resist the enchanting scenery of a back road in France, paved with cobblestone and lined with quaint shops and cafés? This street in Dinan is the perfect representation of an authentic French experience, complete with gorgeous architecture and locals going about their daily routines. Painting this scene may be your biggest challenge yet, but it's important that you try. Remember, you can't grow as an artist without challenging yourself!

As with any architecturally detailed subject, a proper knowledge of perspective is required to execute this painting. This scene also contains people at a fairly close range, so I took the time to draw major guidelines on my paper before I began. I laid in the sky using the wet-in-wet technique and established other areas by laying a series of graded washes to indicate value change and suggest depth.

Thumbnail Value Sketch

MATERIALS LIST

Surface	300-lb. (640gsm) cold-pressed paper
Brushes	No. 8, 12 and 26 round
	1-inch (25mm) flat
Watercolors	Alizarin Crimson
	Brown Madder
	Burnt Sienna
	Cadmium Red Light
	Cadmium Yellow Medium
	Cerulean Blue
	Phthalo Violet
	Raw Sienna
	Sap Green
	Ultramarine Blue
Other	HB pencil

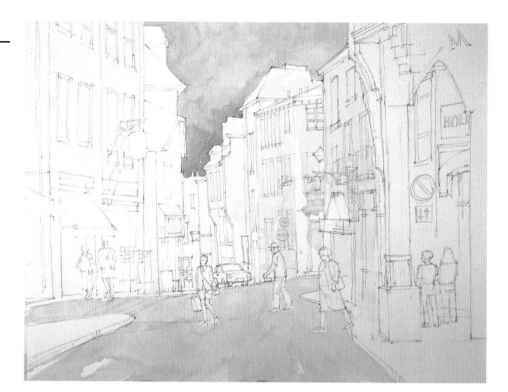

1 Lay in Sky and Street
Using your HB pencil, draw the scene on your paper, including as much detail as possible. Then painting wet-on-dry, lay in the sky using your no. 26 round and a light gray mixture of Cerulean Blue, Alizarin Crimson and Cadmium Yellow Medium, working from top to bottom. Add more Cerulean Blue to the bottom, painting wet-in-wet to suggest a sense of depth. Lay a light, creamy wash over most of the lighter buildings using your 1-inch (25mm) flat and a mixture of Cadmium Yellow Medium, Alizarin Crimson and Ultramarine Blue. Paint the street with a darker mixture of the same colors, adding more Ultramarine Blue in the immediate foreground to make it cooler and slightly darker.

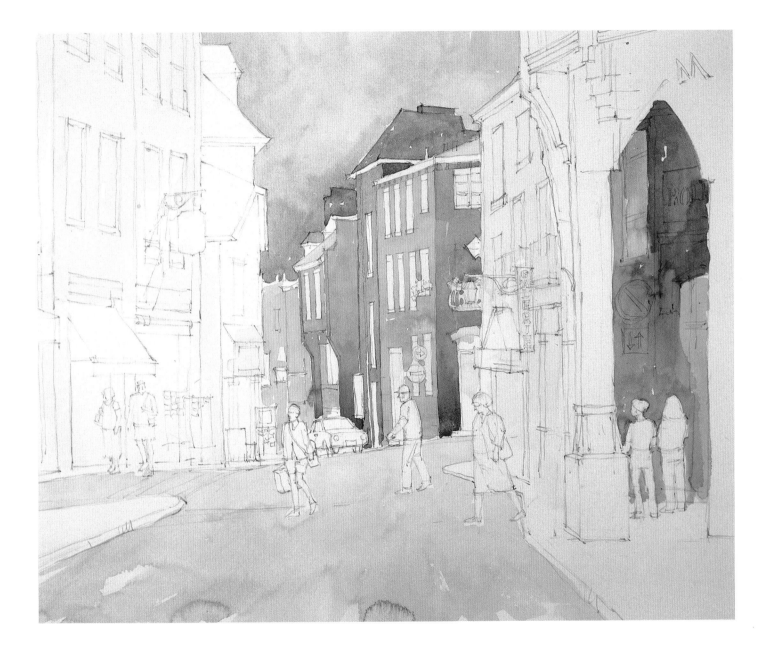

2 Develop Buildings on Right Side of Street

Paint the roof tops at the center of the picture using your no. 12 round and combinations of Ultramarine Blue, Burnt Sienna and Brown Madder. While still wet, introduce touches of Cerulean Blue, allowing the colors to mix on your paper. Use the same brush and blue-violet mixture to paint the building in the exact center of the picture. Lay in the buildings directly to the left and right of this center building using mixtures of Burnt Sienna, Ultramarine Blue and Cadmium Yellow Medium. Carefully paint around windows and doors, using masking fluid if necessary. While still wet, gradually add Brown Madder to the two buildings on either side of the center building, working from top to bottom with your no. 12 round.

Using the same brush and colors, lay a second wash over the right side of the building directly right of center, creating the illusion that the building wraps around a corner. Add more Ultramarine Blue to the bottom to darken and cool. Next, paint the area behind the archway using your no. 12 round and various mixtures of Ultramarine Blue, Brown Madder and Burnt Sienna. Allow the colors to flow and run together, creating a base wash for this area. Then paint the glass doorway using Cadmium Yellow Medium subdued with hints of Phthalo Violet.

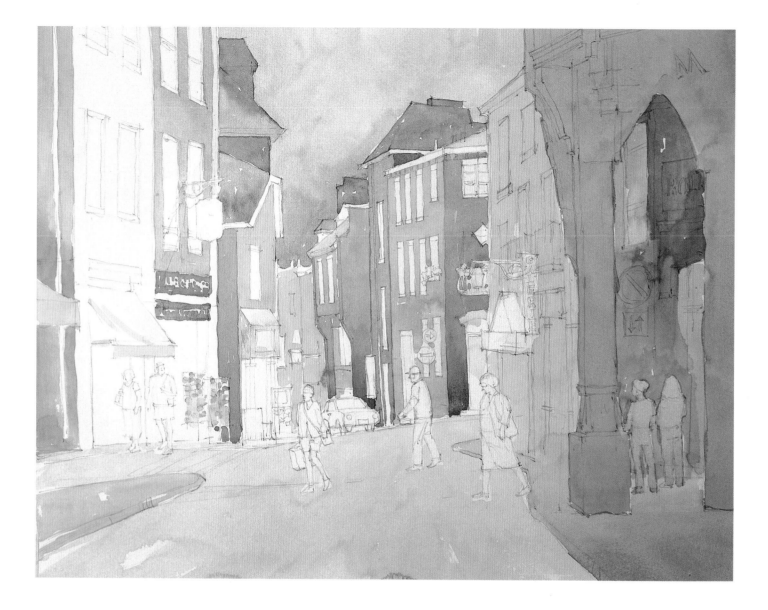

3 Lay in Arch and Begin Buildings on Left

Still focusing on the right side of the street, lay a warm wash of Ultramarine Blue, Burnt Sienna and Cadmium Yellow Medium over the building directly next to the archway using your 1-inch (25mm) flat. Paint the arch using the same brush and a mixture of Burnt Sienna, Ultramarine Blue and Cadmium Yellow Medium. Lay a wash of Ultramarine Blue, Phthalo Violet and Burnt Sienna over the sidewalk beneath the arch, adding more pigment to darken the foreground. Then using your no. 12 round and a grayed mixture of Ultramarine Blue and Burnt Sienna, paint the two figures standing under the arch.

Now moving to the left side of the street, paint the roof on the building farthest from the viewer using your no. 12 round and a mixture of Ultramarine Blue and Burnt Sienna. Then paint the roof directly next to this using Ultramarine Blue and Sap Green.

Still using your no. 12 round, lay in the brick walls of these two buildings using various combinations of Burnt Sienna and Ultramarine Blue. Paint the face of the building directly left of the brick buildings using Burnt Sienna and Ultramarine Blue. Then paint the two signs beneath the face of this building using Cadmium Red Light above and a mixture of Ultramarine Blue and Sap Green below. Next, lay a warm wash of Burnt Sienna, Ultramarine Blue and Phthalo Violet over the building to the extreme left. Paint the two canopies using Ultramarine Blue and Raw Sienna, and lay in the sidewalk using Cadmium Yellow Medium, Ultramarine Blue and Burnt Sienna. Finally, suggest the postcard stands on the sidewalk using Cadmium Red Light, Cadmium Yellow Medium and Ultramarine Blue, as well as grayed mixtures of these colors. Let this dry.

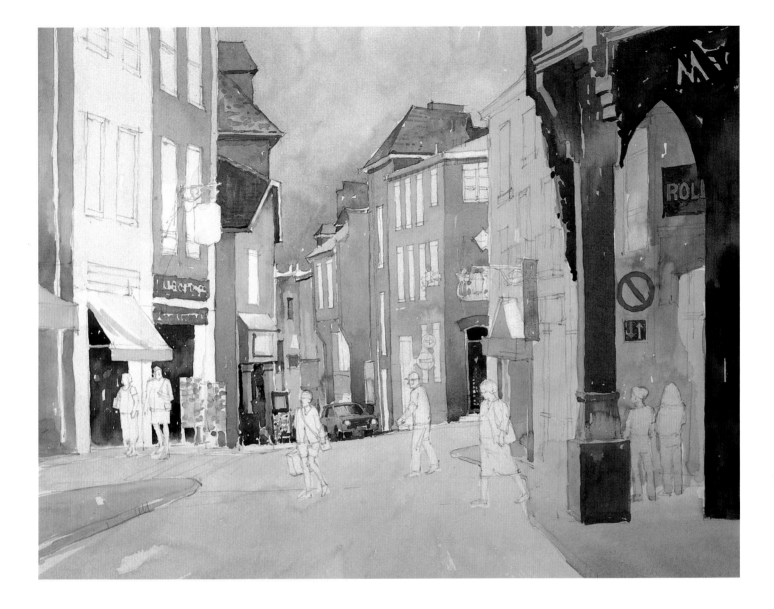

4 Paint Shop Interior, Signs and Other Details

Paint the interior of the two shops on the left using your no. 12 round and pure Burnt Sienna. While wet, drop in a mixture of Ultramarine Blue, Phthalo Violet and Burnt Sienna, allowing the colors to flow together and indicate action inside the shops. Use Sap Green, Ultramarine Blue and Burnt Sienna to detail the columns and projecting overhang directly to the right of these shops. Indicate the doorway between these columns using Ultramarine Blue and Burnt Sienna. Add another postcard stand next to this doorway using the same colors from step 3.

Moving back to the right side of the street, paint the car using your no. 12 round and various mixtures of Ultramarine Blue and Burnt Sienna. Using the same brush, lay a dark mixture of Ultramarine Blue and Raw Sienna into the doorway of the building that wraps around the corner. Use Cadmium Red Light and

Alizarin Crimson to indicate the sign above this doorway. Then with the same brush and colors, paint the canopy, doorway and Galerie sign behind the woman stepping into the street (just slightly right of center). Shape the large foreground archway and columns, adding Brown Madder highlights to create depth. Follow this with a dark mixture of Ultramarine Blue, Brown Madder and Burnt Sienna to indicate shadows and recesses. Paint some of the sign detail under the arch using your no. 8 round and Cadmium Red Light, Brown Madder, Burnt Sienna and Cadmium Yellow Medium. Then define the roofs of buildings on both sides of the street, indicating shingles and shadows around the eaves with your no. 8 round and various mixtures of Ultramarine Blue and Burnt Sienna.

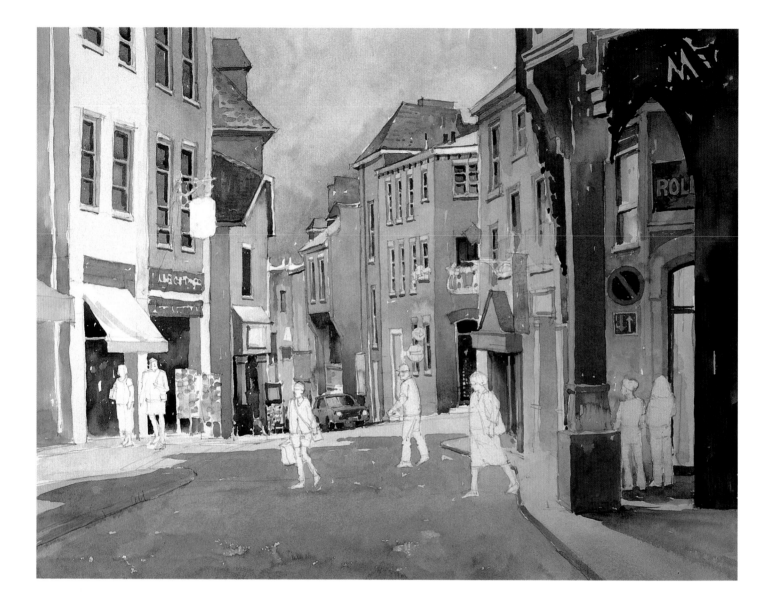

5 Refine Windows and Other Details

Indicate the frame of the glass door behind the arch using your no. 12 round and Phthalo Violet, Burnt Sienna and Ultramarine Blue. Using the same brush and mixture, darken the areas around the door and the highest sign beneath the arch, and lay shadows on the sidewalk. Continue to move down the right side of the street, painting the small gable roof of the building between the arch and the Galerie sign using a mixture of Ultramarine Blue and Burnt Sienna. Add shadows to the doorway and beneath the eaves of this building with a mixture of Phthalo Violet, Burnt Sienna and Ultramarine Blue. Paint the window panes using your no. 8 round and Ultramarine Blue and Burnt Sienna, saving the white of your paper to indicate the window frames. Lay in shadows under the window sills using a mixture of Burnt Sienna, Ultramarine Blue and Phthalo Violet. Indicate all other windows in the painting in a similar

fashion. Next, paint the top of the arched canopy next to the Galerie sign using Burnt Sienna, Brown Madder and Cadmium Yellow Medium. Use the same colors to shade the column on this building. Add touches of Raw Sienna on the small lamp and sign attached to this building. Then paint the roof vents on the building that wraps around the corner using your no. 8 round and a mixture of Burnt Sienna, Brown Madder and Ultramarine Blue. Darken the recessed area of the cantilevered building directly left of the building in the center of the painting using a mixture of Ultramarine Blue, Burnt Sienna, Brown Madder and Phthalo Violet. Darken the street using your no. 26 round and a mixture of Ultramarine Blue, Raw Sienna and Phthalo Violet, adding more pigment to the immediate foreground. Let your paper dry.

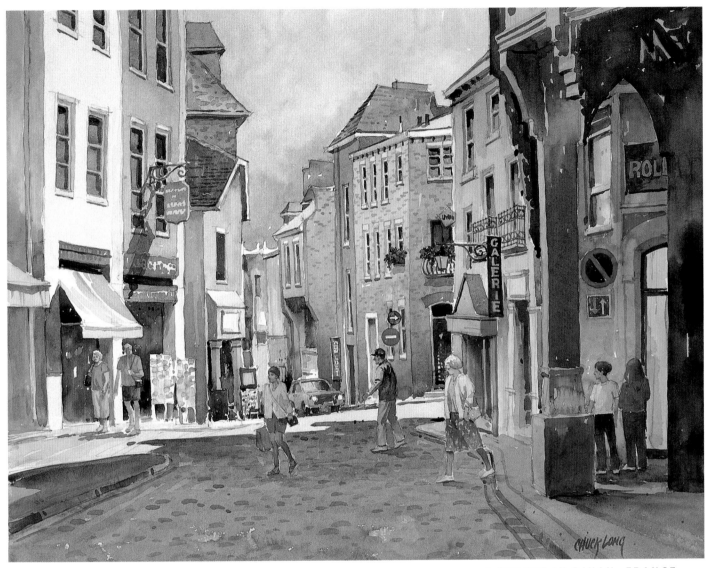

A STREET IN DINAN, FRANCE
15" X 22" (38CM X 56CM)

6 Add Finishing Touches

Paint signs, lamps, planters and balconies using your no. 8 round and appropriate colors. Indicate the tile above the canopy at left using Burnt Sienna, Brown Madder and Ultramarine Blue. Darken the recess beneath the canopy with the same mixture and touches of Phthalo Violet. Add ripples to the canopy on the far left using Phthalo Violet, Burnt Sienna and Ultramarine Blue. Use the same brush and colors to give depth to the wall below. Paint the girls on the right with Cadmium Red Light and Cadmium Yellow Medium for flesh, and Ultramarine Blue, Burnt Sienna and Phthalo Violet for clothes. Use Cadmium Red Light, Cadmium Yellow Medium and Phthalo Violet for flesh tones on all other people. Lay in Cerulean Blue, Ultramarine Blue and Burnt Sienna for the coat and hat on the man in the center and Raw Sienna, Burnt Sienna and Phthalo Violet for his pants. Paint the girl in the center with Cadmium Red Light and Raw Sienna grayed with Phthalo Violet for her shirt, and Cadmium Red Light, Alizarin Crimson and Phthalo Violet for her head piece and shorts. Add various browns and violet for her shopping bag, handbag and sandals. Paint the hair, skirt, jacket, handbag and shoes of the woman stepping into the street with combinations of Raw Sienna and Ultramarine Blue. Use Alizarin Crimson and Brown Madder overpainted with Cerulean Blue to create her patterned skirt. Lay in the two people at left using Cadmium Red Light, Alizarin Crimson and Phthalo Violet for the shirts and dress, and Ultramarine Blue mixed with Burnt Sienna for the shorts, handbag and cameras. Darken the foreground slightly and add cobblestone texture using your no. 12 round and Ultramarine Blue, Burnt Sienna and Phthalo Violet. Add brick and stone texture to several buildings using the same colors.

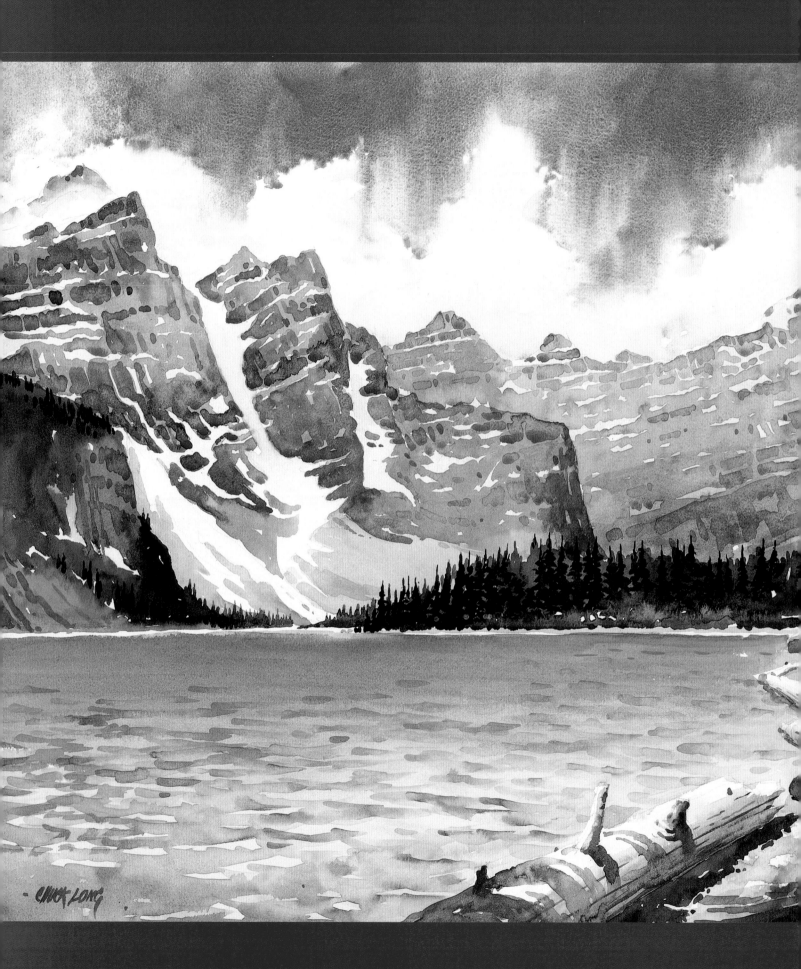

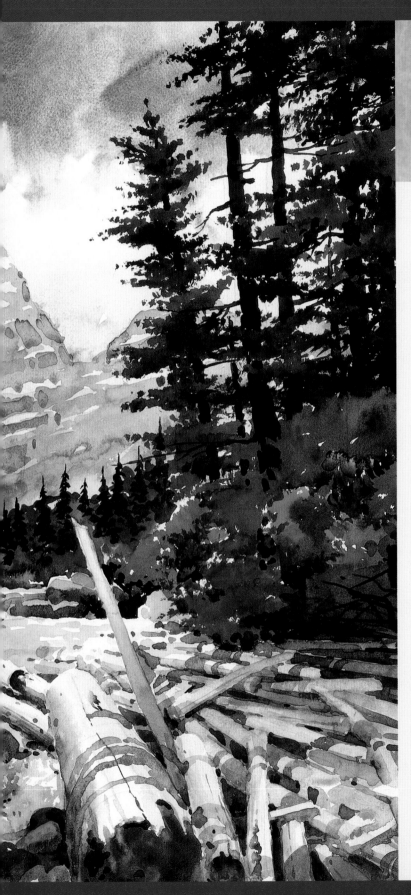

AUTHOR'S AFTERTHOUGHT

I sincerely hope that you have enjoyed this book as much as I have enjoyed writing it. I hope also that it has been of some assistance to you along the road to becoming proficient in watercolor painting. The road can be bumpy. It requires much hard work and practice, but most of all it requires desire. If you want to be a good watercolorist and if your desire is strong enough, the practice and work will come easily.

Watercolor is the grandest illusion. It sparkles and glows with light and has qualities that I find lacking in other art media. I would suggest that you let such qualities be your guide and your inspiration. Aim high and shoot straight—reaching the promised land of watercolor is a worthy goal!

MORAINE LAKE
15" X 20" (38CM X 51CM)

INDEX